FLOWERS
CHARLES RENNIE
MACKINTOSH

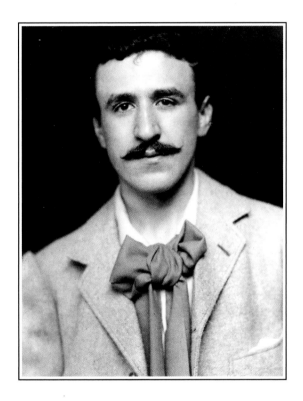

Text by Pamela Robertson

Harry N. Abrams, Inc., Publishers

TO DAD, WHO HAS GIVEN US ALL SO MUCH

Designed by David Fordham

Library of Congress Cataloging-in-Publication Data

Robertson, Pamela, 1955–
 Flowers: Charles Rennie Mackintosh/Pamela Robertson.
 p. cm.
 Includes bibliographical references (p.) and index.
 ISBN 0–8109–3333–0
 1. Mackintosh, Charles Rennie. 1868–1928 – – Exhi-
 bitions.
2. Botanical illustration – – Exhibitions. 3. Flowers in
art – – Exhibitions. 4. Hunterian Art Gallery (University
of Glasgow) – – Exhibitions. I. Title.
QK98.3.R64 1995
582. 13′022′2 – – dc20 95–1748

First published in Great Britain in 1995 by Pavilion Books
Limited, London, in association with the Hunterian Art
Gallery, University of Glasgow, under the title *Art is the
Flower*

Published in 1995 by Harry N. Abrams, Incorporated,
New York
A Times Mirror Company

Printed and bound in Italy

PLATE 1, PAGE 1
TEXTILE DESIGN: CHEQUERED WAVE PATTERN — RED,
BLUE AND BLACK, *c.* 1922
Pencil and watercolour

THOUGH INSCRIBED 'SEFTON', two related designs were
being produced as voiles in 1922 by W. Foxton.

PLATE 2, PAGE 2
FRITILLARIA, WALBERSWICK, 1915
Pencil and watercolour

IN SOUTHERN BRITAIN, as an indigenous plant, fritillaria
(*Fritillaria meleagris*) is a rarity of ancient
damp pastures. However, it is commonly grown
in gardens.

PLATE 3, PAGE 3
CHARLES RENNIE MACKINTOSH, *c.* 1893

THIS EARLY PORTRAIT, by the progressive Glasgow
photographer James Craig Annan, shows
Mackintosh in self-consciously artistic attire.

CONTENTS

AUTHOR'S NOTE

'Art is the flower – life is the green leaf. Let every artist strive to make his flower a beautiful living thing – something that will convince the world that there may be – there are – things more precious – more beautiful – more lasting than life.'

Charles Rennie Mackintosh, 'Seemliness', 1902

ECTURING IN 1902 ON THE SUBJECT OF 'SEEMLINESS', MACKINTOSH CHALLENGED HIS audience of artists and writers to fulfil their full potential, to achieve work of beauty and of relevance, work which would by its quality outlive its creators. His culminating image was Art as a flower, nourished and supported by the green leaf of life. That a flower was selected as the central symbol in this artistic argument hints at the significance of plant forms, and in particular flowers, for Mackintosh. This book explores the role they played in his work, as Mackintosh himself strove to make 'things more precious – more beautiful – more lasting than life'.

The book is based on a catalogue for an exhibition of Mackintosh flower drawings, presented in 1988 as the Hunterian Art Gallery's contribution to the third British Garden Festival held that year in Glasgow. Its scope, though, is wider and includes consideration of all of the ways in which Mackintosh used plant forms in addition to discussing the botanical paintings. The book concentrates on Mackintosh's wide-ranging graphic depictions, from the early pencil studies to the late, glorious still-life compositions and vivid textile designs. The final chapter examines Mackintosh's use of plant forms as a designer, placing this in the context of late nineteenth-century design theory.

NOTE ON TITLES OF WORKS

DISTINCTION HAS BEEN MADE IN THE MAIN TEXT BETWEEN TITLES PROVIDED BY Mackintosh in his lifetime and those given by subsequent scholars, by placing original titles in inverted commas. Generally the post-humous titling acts as a useful descriptive aid. But with certain works, notably the symbolic and imaginative paintings of the 1890s, for example those now titled *The Shadow* or *In Fairyland*, it may obscure Mackintosh's original meaning.

ACKNOWLEDGEMENTS

I N PREPARING THE ORIGINAL CATALOGUE AND THIS BOOK, I AM DEEPLY INDEBTED TO many colleagues and friends. I would like to thank in particular the following: all of my colleagues at the Hunterian, particularly Chris Allan and Martin Hopkinson for their thoughtful advice, and Denise Pulford for her typing skills and patience; Dr James Dickson, Senior Lecturer in the Botany Department of the University of Glasgow, for his untiring and enthusiastic assistance and scholarship in identifying the plants Mackintosh recorded – in this he was assisted by the staff of the Royal Botanic Garden, Edinburgh, in particular Dr C.N. Page; and finally the staff of Media Services Photographic at the University of Glasgow, who have provided many of the images which enrich the text. Alan Crawford generously read the typescript while battling to complete his. Many others have helped with advice and encouragement over the years. I am indebted to Roger Billcliffe, the Davidson family, Patricia Douglas, Anne Ellis, Jane Lindsey, Andrew Patrick, George Rawson, Daniel Robbins, Richard Scott, George Smith, Peter Trowles and all of those private owners who wish to remain anonymous and who suffer Mackintosh enthusiasts with such grace. I have received great help from the staffs of the Mitchell Library, Glasgow, the National Art Library, the National Library of Ireland and the Print Room of The British Museum. At Pavilion I am grateful to Colin Webb, whose idea it was to develop my early catalogue into a book, and to Mandy Greenfield, who has been a patient and meticulous editor.

Finally to my family – to Jamie and Elizabeth, and above all Bill – thank you for your tolerance and support.

Pamela Robertson
Glasgow, November 1994

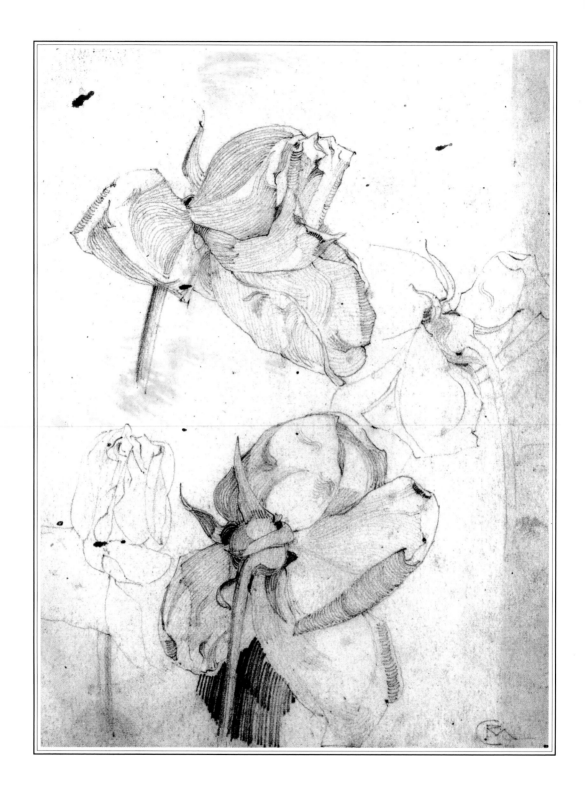

PLATE 4
ROSES, *c.* 1889–93
Pencil

ARCHITECTURAL
DRAUGHTSMAN

'But hang it, Newbery, this man ought to be an artist!'

James Guthrie to Francis Newbery, 1891

I N 1888, FRANCIS NEWBERY, THE NEWLY APPOINTED HEADMASTER OF GLASGOW SCHOOL of Art, lectured to the city's Philosophical Society. His subject was the 'Training of Architectural Students', his text a characteristically eloquent argument in support of drawing. The student's pencil was likened to the marshal's baton that Napoleon had reputedly claimed was tucked inside every soldier's knapsack. With his pencil, the architect 'may command the dull stones of the earth to arrange themselves in ordered masses, and make beauty to live in undying splendour on our walls; may by his proportions lead the thoughts, and by his colours tinge the imagination.'[1] Extravagant words, perhaps, but they underline the emphasis prevalent in British art schools, from their establishment in the mid nineteenth century, on drawing as the vital professional skill for the architect, designer and artist. Glasgow School of Art, Scotland's first Government School of Design, was keenly aware of its responsibility to provide first-rate designers for what was rapidly emerging as the 'Second City of the Empire' on the basis of its outstanding commercial and industrial prowess. In 1886, the Chairman of its Committee of Management declared: 'All our great industries, whether of shipbuilding or house-building, whether of engineering or machine-making, whether of pattern drawing or the higher art of painting, must first have their origin in drawing, and without this basis none of them can be established.'[2]

■ ■ ■ This emphasis on drawing was enshrined in the National Course of Instruction set up in the mid nineteenth century, and disseminated with autocratic method from the Central School at South Kensington. Its twenty-three stages broke down the nurturing of skills in drawing, painting, modelling and design into fifty-six components. Drawing classes, for example, progressed slowly from freehand outline from the flat copy and subsequently the three-dimensional object, to shading from the flat and then the round – all using examples of historic ornament – until in the latter stages the student was finally allowed to work from life or nature.

I N THIS DRAWING, and others from the same sketchbook, hatching of varying weights was used to a much greater extent than in the later drawings. Each study shows a different view of the same flower, a rose cultivar, perhaps a Hybrid Tea.

■ ■ ■ It was to this system that Mackintosh subscribed for over ten years from 1883. As an articled apprentice architect, he worked a full day with the Glasgow practice of John Hutchison, and subsequently, from 1889, of Honeyman & Keppie. The greater part of these years was spent as a draughtsman, copying and working up the senior architects' and partners' designs. In the evenings he attended classes at Glasgow School of Art, studying Mathematics, Mechanics, Building Construction, Geometry, Perspective, Modelling, Drawing and Ornament. His earlier schooling at Allan Glen's Institution in the city centre had already provided a thorough foundation. Allan Glen's was a progressive school which aimed to provide a vocational education for prospective engineers and scientists. Its secondary-level courses concentrated on Mathematics, Science and Drawing. From 1878 it ran a Technical Workshop which gave practical access to woodworking and metalworking equipment for those, like Mackintosh, who continued for a further two years after the general leaving age of fourteen.

■ ■ ■ Mackintosh's formal training therefore gave him little, if any, opportunity for creative or artistic expression. Drawing was instilled as a professional language. Its vocabulary was line rather than stippling or shading; its expression required mechanical precision and scientific knowledge. It was the method best suited to technical drawing. Mackintosh's mastery of this skill was precocious, and quickly recognized both at the School and in the office. In the annual School competitions, run at local and national British level, Mackintosh's name appeared regularly. At national level he won the highest prizes including a Gold Medal and Queen's Prize, and, within the School, free studentships, first-class certificates and other local prizes. At work, in the early 1890s, Mackintosh would be whisked off by John Keppie to his country home in Prestwick to work up competition entries. Mackintosh's drawings soon began to appear in the professional press. The surviving original designs and published illustrations, while not innovative in architectural content, display great technical virtuosity and refinement in the handling of pen and wash.

■ ■ ■ Greater individuality and artistry is seen in the early sketchbook studies, both in technique and in choice of subject matter. Details of architectural construction and form were to be expected, for sketching was by no means simply a recreational habit; it was an essential part of a young architect's training and one which would have been

encouraged in Mackintosh by his antiquarian-minded senior partner, John Honeyman. In an early lecture, Mackintosh conjures up a romantic, and doubtless autobiographical, picture of the inspired young architect struggling 'along muddy roads and snowy path, and with glowing heart but shivering hand to sketch the humble cottage, the more pretentious mansion, or the mutilated though venerable castle with feelings of the most indescribable delight.'[3] Sketching was a vital activity to develop draughtsmanship, skills of observation, knowledge of architectural history and form, and a design vocabulary. Through the late 1880s and the 1890s, Mackintosh made regular trips through Scotland and England, sketching in particular their historic local architecture. Six sketchbooks and almost one hundred dismembered sketchbook drawings document visits in central and northern Scotland, and trips to England, to Somerset, Gloucestershire, Worcestershire, Devon and elsewhere.[4] His skills were honed by a lengthy tour of Italy in 1891 funded by the Alexander Thomson Travelling Studentship. The Studentship's remit was specifically to enable study through drawing. Mackintosh's energetic schedule over four months took him to major centres the length of Italy. He regularly visited and sketched several sites in one day. By the end of the tour, the tight mechanical line of the early studies from Pompeii and Naples had developed into an expressive and vibrant outline. It was the public display of a selection of these studies on his return to Glasgow which reputedly prompted one of the assessors, the leading Glasgow Boy painter James Guthrie, to exclaim to Newbery, 'But hang it, Newbery, this man ought to be an artist!'

■ ■ ■ Other indications of Mackintosh's more artistic interests were contained elsewhere in the sketchbooks. Often interspersed with the architectural sketches were exquisite studies of plant forms. Some twenty drawings survive in three sketchbooks from the mid 1890s, all at the Hunterian Art Gallery, but the earliest known studies are contained in a newly discovered sketchbook at Glasgow School of Art. This sketchbook contains fourteen pages of flower studies, the majority of which are by Mackintosh. Two – *Daffodils* and *Roses* (PLATE 4) – are signed with the linked 'CRM' monogram used on architectural studies of the late 1880s and early 1890s. If this approximate dating is correct, then these drawings could well be Mackintosh's earliest surviving botanical sketches.

■ ■ ■ Mackintosh's plant studies are based on sound scientific understanding. *'Evening Primrose'*, for example, combines key elements of the plant: the flower, capsule, whorl of stamens, calyx and a leaf (PLATE 5). In *'Foxglove, Corrie, Arran'* (PLATE 6) Mackintosh records in sequence the profile of an opening lip of a foxglove bloom. But as important as the accurate recording of the subject is its decorative organization. Mackintosh uses outline and hatching – the devices of the trained draughtsman, but the grace of the line, the carefully judged positioning of the drawing on the page, the use of hatched details as punctuation and of decorative idiosyncratic lettering and the wilful overlapping of outlines all contribute to the whole as work of art. In Mackintosh's drawings the almost self-conscious beauty of the draughtsmanship rivals that of the subject itself. While working within, not abandoning, standard South Kensington vocabulary, Mackintosh was creating an individual language.

■ ■ ■ *'Foxglove, Ascog'* (PLATE 7) reveals another aspect to these early drawings. A less formally composed study, it presents further details of the foxglove with, at bottom centre, a rough outline of an acanthus scroll. Of particular interest is the motif at lower left – a symmetrical device composed of foxglove anthers. This motif directly reflects South Kensington's teaching on the ordering of nature to produce good ornament. Mackintosh was concerned not just with the scientific analysis and recording of plant forms, but also with their potential as a resource for design ornament.

■ ■ ■ Recently another previously unrecorded sketchbook has been located at the National Library of Ireland. This is devoted exclusively to flower studies and contains thirteen pencil drawings. The majority were executed locally in Scotland – in Glasgow, Bute and West Kilbride. Those that are dated are from 1895. The drawings fill one, sometimes two, pages of the sketchbook and include studies of a Christmas rose, a gooseberry, flowering currant, candytuft, Canterbury bells and lilies (PLATE 8). They present characteristically decorative compositions in which the structure and form of the plants are analysed with the same degree of care as a Gothic church tower or a castle buttress. The spelling is at times idiosyncratic and the layout of the lettering often done with wit. In one the stem incorporates a superimposed 'MM' – for Margaret Macdonald, perhaps; in another the extended tail of a 'Y' becomes a spider's thread from which dangles a tiny spider.

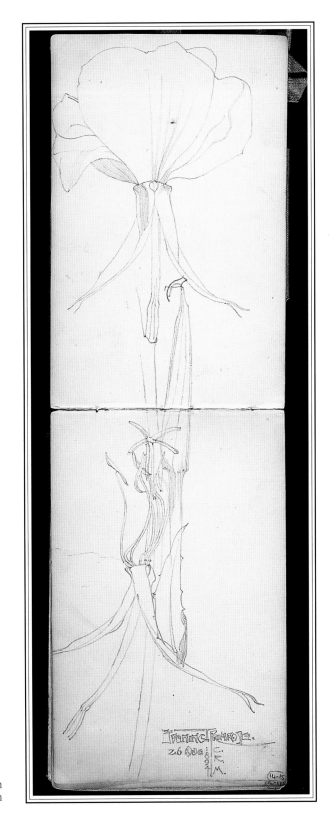

THE SPECIES is perhaps *Oenothera glaziouana*, which commonly grows in roadsides and waste ground in England, less commonly in Scotland.

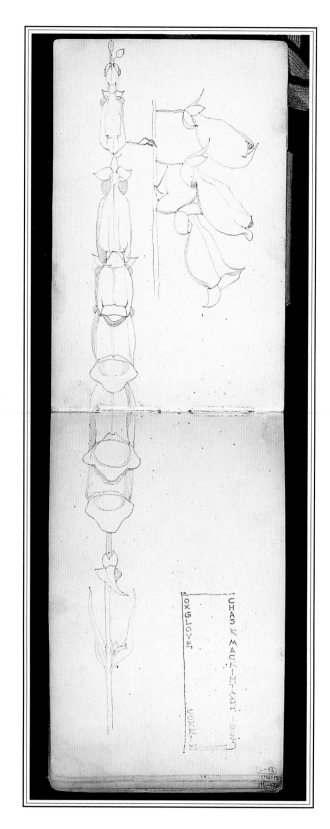

PLATE 6
FOXGLOVE, CORRIE, ARRAN, 1895
Pencil

*D*IGITALIS PURPUREA is common in woodland clearings,
heaths and gardens.

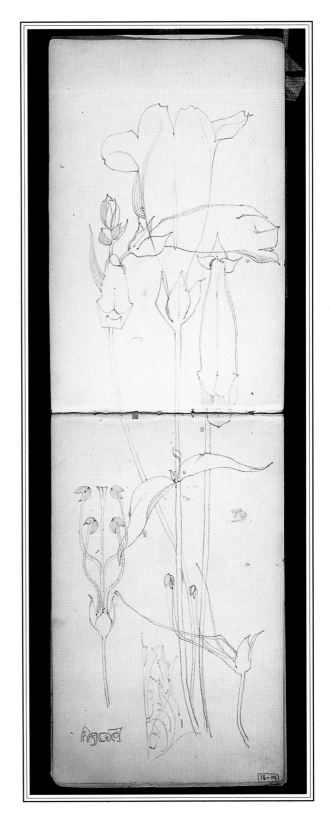

PLATE 7
FOXGLOVE, ASCOG, BUTE, *c.* 1894–5
Pencil

A<small>T BOTTOM LEFT</small> Mackintosh has followed South Kensington teaching and ordered the foxglove anthers into a symmetrical motif.

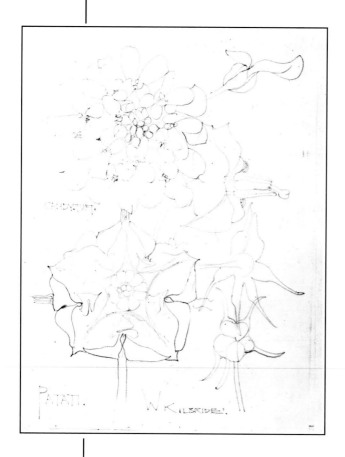

PLATE 8
FLOWERS, WEST KILBRIDE, 1895
Pencil

THE DUBLIN sketchbook contains six studies of flowers made in West Kilbride, a small town south-west of Glasgow near the Clyde coast. This page records the annual candytuft and stylized potato flowers.

■■■ This is the only known sketchbook devoted exclusively to flowers, but it may well not have been unique. Its existence perhaps explains the puzzling lack of flower studies from the Italian tour. Although this took place in the bloom of spring and early summer, Mackintosh's two surviving Italian sketchbooks contain no flower studies. Perhaps these were drawn in separate sketchbooks now lost? The existence of the Dublin sketchbook also reinforces the importance Mackintosh attached to his botanical drawings and suggests he may have been developing a study collection of floral illustrations to be referred to by himself, and possibly also his designer friends. On the last page, for example, is a study of honesty seeds dated 1895 – a motif used by Mackintosh to decorate a linen cupboard of 1896 and also used by Frances Macdonald for beaten metalwork and watercolour panels of the same period.

■■■ Drawing flowers was to become a life-long habit. While other architects, including Keppie (and Mackintosh himself), would paint and exhibit generally topographic watercolours, it was less usual for a professional man to take up what was widely viewed as a 'feminine fancy'. But this was for Mackintosh an essentially private habit. It was not until 1914 that he began to conceive flower studies specifically for publication or exhibition.[5]

■ ■ ■ Mackintosh's love and understanding of plant forms had been encouraged from an early age. As a child, with his brothers and sisters, he had had access to what they christened 'The Garden of Eden', the grounds of Golf Hill House, Dennistoun, Glasgow, in which his father, an enthusiastic gardener, held a part share. His earliest recorded sketchbooks, now lost, date from the age of eighteen; some of their pages were shared with an artistic cousin, Margery McIntosh. Mackintosh's fellow apprentice at Honeyman & Keppie, James Herbert McNair, would later recall how Mackintosh would go to any lengths to secure a twig, branch or flower whose colour or shape had caught his attention – even if it grew in a private garden.

■ ■ ■ While flower drawing was not a prescribed part of an architect's training at Glasgow School of Art, it is significant that Mackintosh took it up shortly after joining the School. The role of the School was to be crucial in his development as an artist. Its stimulating environment contained fine art studios, a flower painting room, a well-stocked library and talented students. The School was then housed under the same roof as the Corporation Art Galleries, with its impressive displays of French, Dutch, Flemish, Italian and British masters. A few hundred yards away in Sauchiehall Street, the Glasgow Institute of the Fine Arts' handsome new building held annual shows of contemporary work by its members, and by invited artists including leading Pre-Raphaelites, Whistler and his followers, and Dutch and French Realist painters. From the year of its opening the Institute housed the School of Art Club's annual exhibition. The Corporation Galleries block formed then, as now, part of the city centre's hub of dealers and artists' studios. In 1890, for example, R.M.G. Coventry, David Gauld, James Guthrie, George Henry, E.A. Hornel, John Lavery and E.A. Walton all had studios nearby. These studios were interspersed between the premises of dealers and auction-eers such as Annan; Morrison, Dick & McCulloch; and Edmiston's.

■ ■ ■ Arguably more significant than this was the formative role of Newbery, the eloquent and progressive educator, and himself a painter. His remarkable qualities were singled out by *The Studio* in 1900: 'The originality and strength of his personality, and the freshness and vigour in his manner of regarding artistic questions, become strongly conducive to originality in the students who pass through the school. His unwillingness to tolerate anything merely conventional or common-place,

and his encouragement of original effort are most important factors in forming the taste and settling the convictions of the pupils.'[6] While his role as a pioneer of Technical Design has been widely discussed, Newbery also worked to promote Fine Art within the School. In 1886, for example, just a year after his appointment, he set up the Glasgow School of Art Club. Under his direction the club involved both past and present students of the School. It ran open-air sketching classes, organized monthly competitions for figure and landscape compositions and vacation work, and held annual exhibitions and 'Conversazione' receptions after the summer vacations. Mackintosh actively participated in the Club as an exhibitor and, on at least one occasion, as a designer of its graphics (PLATE 20). Newbery himself taught drawing classes from life and the antique, lectured on Artistic Anatomy and encouraged the active involvement as assessors of the young and innovative Glasgow Boy painters, then at the peak of their international reputations.

■ ■ ■ As an educator, Newbery was not a slave to the South Kensington regime. While he was ambitious for the recognition which success within its examination system would bring the School, he also recognized the importance of creative independence. 'Kensington,' he once exclaimed to a Glasgow reporter in 1895, 'I recognize no such thing as Kensington!'[7] Newbery believed that each Government School was free to interpret the South Kensington curriculum as it saw best. In his view, Schools of Art were not design factories for specific manufacturers, but artistic institutions from which designers emerged not full of ready-made ideas, but as educated workmen at the service of any manufacturer. His independent views are typified by his attitude to drawing. In draughtsmanship, while line was for him paramount, his was a more creative definition, as the Philosophical Society heard: 'I would have [the architectural student] draw with pencil, pen and sepia, from fillet to temple and from Gothic leaf to Cathedral, not as studies merely to enable him to have a command over his pencil, but, under instruction, seeking out and comparing their hidden beauties and subtle boundaries, till he realize what is meant by the power of a line which is neither crooked nor straight, arched nor horizontal, and the beauty of a proportion untrammelled by rules and yet capable of the highest mathematical exactitude.'

■ ■ ■ While such views would have encouraged Mackintosh in developing his draughtsmanship beyond the merely technical, his immediate circle would have provided further encouragement, for many were painters. McNair, Mackintosh's close companion and fellow apprentice architect, was a frustrated painter who had entered the profession principally to appease his family, but only after enjoying a year in Rouen at the studio of the painter Haudebert.[8] Other close friends included the Glasgow Boy painter David Gauld, for whose wedding Mackintosh designed a suite of furniture in 1893, and the highly talented Glasgow painter John Quinton Pringle. E.A. Hornel, one of the most progressive Glasgow Boy painters in the late 1880s and early 1890s, was a close friend of John Keppie. Mackintosh's studio-bedroom was decorated not with architectural illustrations, but with the then fashionable Japanese prints and reproductions of Pre-Raphaelite paintings.

■ ■ ■ Nevertheless, though informed about progressive trends in painting, Mackintosh at this stage conformed to conventional standards of subject matter and technique. It was to take the coincidence of the publication of startling new work in a newly established art periodical, and of contact with the innovative work of students newly arrived at the School, to precipitate this artistic and technically accomplished student into producing a group of experimental and radically different work.

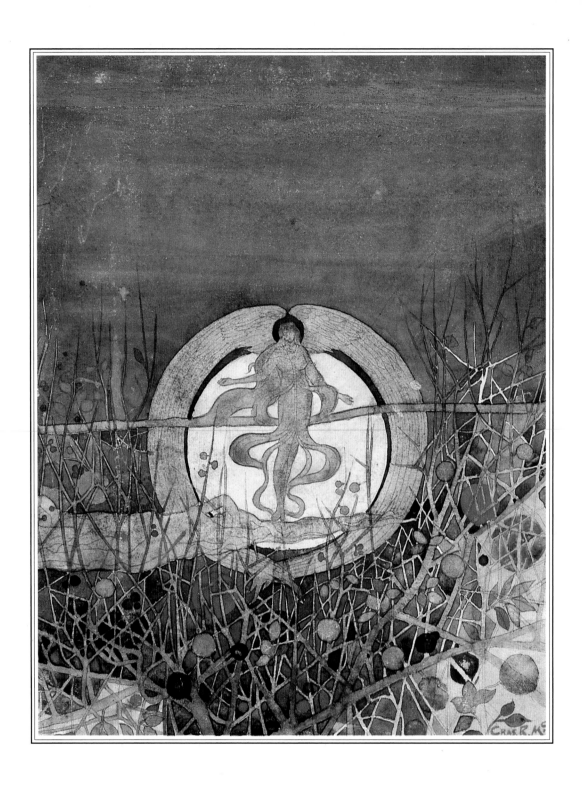

PLATE 9
THE HARVEST MOON, 1892
Pencil and watercolour

STYLIZED
PLANT FORMS

'True originality can never be snuffed out by any dead weight of tradition, like murder "It will out".'

Janet Aitken, 'The Magazine', 1893

BETWEEN 1892 AND 1896, MACKINTOSH PRODUCED A SMALL GROUP OF WATERCOLOURS – less than a dozen survive – which present decorative and symbolic stylizations of plant forms, flooded with colour. In many ways these works were a one-off, a short-lived experiment, the majority of which were never intended for the wider public gaze, but confined to the pages of a hand-written 'magazine' compiled by a student at the School of Art. 'The Magazine' and its artistic coterie stimulated Mackintosh to move beyond the scientific accuracy of his botanical sketches, and to experiment with stylizations of the abstracted elements of flower, stem or leaf. The results were astonishingly diverse in technique and content, ranging from whimsical cabbages and decorative linear patterns to stylized trees that were symbolic of personal effort and professional influence.

■ ■ ■ Four numbers of 'The Magazine' survive, for November 1893, April and November 1894 and the Spring of 1896. Other volumes – containing, for example, the missing second chapter of the fairy-tale adventure 'The Dark Tower' – have not been traced. The preface to number one outlines the ambitions of the new work: 'The Editress has much pleasure in introducing to you the first number of this Artistic and Literary magazine, which she hopes to continue throughout the winter, if sufficiently supported.' No scrapbook or family album this. Though given no formal title, never intended for reproduction, and with a circulation probably confined to the contributors and their friends, each unique number was conceived as a 'magazine'. The Editress, Lucy Raeburn, presented her texts in uniform manuscript, set in ruled boxes, with a cover, frontispiece, headers and tailpieces, with texts and illustrations relevant to the season, and topical reviews. The format was undoubtedly influenced by current art periodicals, in particular the newly launched magazine *The Studio*. It is surely no coincidence that the first volume of 'The Magazine' appeared just months after the first issue of *The Studio*. An earlier exemplar, less for its content than for its ambitions

THE HORIZONTAL WRAITH of cloud passing in front of the moon contains the outline of a reclining nude, elbow upturned, hair streaming in front. The pose has been taken from Alexandre Cabanel's celebrated French Salon painting, *'The Birth of Venus'*, of 1862. Another raised elbow at the left suggests a procession of these figures.

as the literary production of a group of young artists, was the periodical *The Germ*, conceived and published in 1850 by the newly formed Pre-Raphaelite Brotherhood.
■ ■ ■ The core contributors throughout were a group of young women friends: Lucy and Agnes Raeburn, Katherine Cameron, Jane Keppie, Jessie Keppie and Janet Aitken. All were students at Glasgow School of Art. Subsequent issues contained contributions from other students, poetry by the ever-supportive Francis Newbery under the pseudonym 'Elliot', and the occasional contribution from outsiders such as the successful painter and printmaker D.Y. Cameron (no doubt encouraged by his sister Katherine) and the photographer James Craig Annan (no doubt encouraged by his good friend D.Y. Cameron). It was a close-knit coterie, the girls forming part of the self-titled group 'The Immortals', which included Mackintosh and McNair, and which would regularly visit the Keppie family home in Prestwick. John Keppie, Jessie's brother and Mackintosh's employer, is a conspicuous absentee from the pages of 'The Magazine'. Though only a few years older than the others and happy to be host and mentor, Keppie appears to have chosen not to contribute to the informal artistic endeavours of these younger, and mainly female, students.
■ ■ ■ The literary content of 'The Magazine' was not distinguished and was largely provided by the female contributors. Their narratives may contain coded references, now obscure, to individuals and relationships within the group. The fiction revolves round fairy-tales and whimsical stories of tragic death, valour and love – usually unrequited, while the stereotypical sweetness and beauty of the heroines stand in sharp contrast to the visual imagery of two of the contributors, Margaret and Frances Macdonald. Topical issues at the School were aired. In the first number, for example, Janet Aitken contributes 'Some Words on Originality' in which she exhorts her readers: 'Let us have originality by all means, but not at all costs, for then it degenerates into mere singularity. True originality can never be snuffed out by any dead weight of tradition, like murder "It will out".' Her words uncannily anticipated the illustrations of later numbers. Generally the illustrations were black and white line drawings, used as graphic devices or textual illustrations. The outstanding exceptions were the watercolours incorporated in the 1894 and 1896 numbers by Mackintosh and the Macdonald sisters.

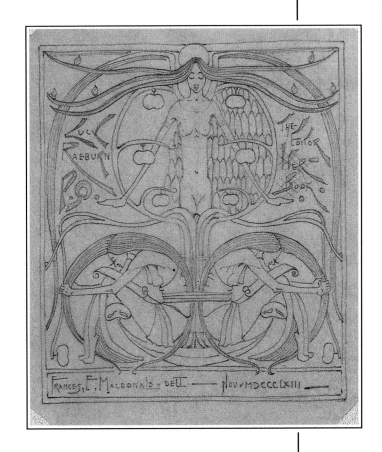

PLATE 10
FRANCES MACDONALD
(1874–1921)
Frontispiece for 'The Magazine', 1893
Pencil on brown
tracing paper

MARGARET MACDONALD used a closely re-
lated design, but with the figures facing
each other, for an invitation card to the
Glasgow School of Art Club 'At Home' in
November 1893.

■ ■ ■ The English-born sisters had attended the School as day-students from 1890
and by 1893, if not earlier, had been introduced to Mackintosh and McNair by Newbery
as like-minded students. No dated work by either sister before 1893 survives. But their
'Magazine' illustrations reveal a remarkable individuality and accomplishment, and
a preoccupation with symbolism and innovative stylizations of plant forms and the
human figure which surpass Mackintosh's contemporaneous work.

■ ■ ■ The earliest of the sister's contributions – the only example in the first
number – is a bookplate by Frances Macdonald for the new editor, Lucy Raeburn
(PLATE 10). The scoring through of 'Her Book' may have been done as acknowledge-
ment of the plate's inclusion as a frontispiece. The design was repeated for Frances
herself, and possibly other of The Immortals, and adapted for the programme of the
forthcoming Glasgow School of Art Club 'Conversazione' through the substitution of
the two crouching figures' scrolls for a palette and lyre respectively. The formal
language of the design was therefore disseminated within, and presumably accepted
by, the group. In it two reading figures sit, bound to the foot of a personification of
a fruitful Tree of Knowledge. Stylistically the controlled but flowing outline, careful
hatching and experimental lettering are related to Mackintosh's contemporaneous

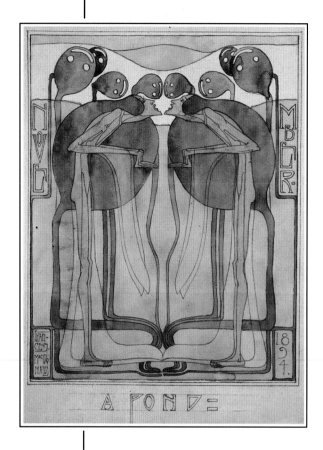

PLATE 11
FRANCES MACDONALD
A POND, 1894
Pencil and watercolour on brown tracing paper

THE ICONOGRAPHY of this watercolour is not certain, but it is possible that the winged insects represent dragonflies or damselflies. In their nymph state, these prey on young pondlife, such as tadpoles – perhaps the creatures depicted in the background. If so, the watercolour can be read as illustrating the morbid theme of predatory life and death.

work, while the preoccupation with organic growth, the seamless merging of human and plant forms, the reduction of both to decorative motif, and the considered use of imagery, were all to become characteristics of the work of the Macdonalds, Mackintosh and McNair – a grouping subsequently dubbed 'The Four'. These concerns are strikingly developed in the most startling of the sisters' work for 'The Magazine', Frances Macdonald's 'A Pond' (PLATE 11).

■ ■ ■ 'Cabbages in an Orchard' (PLATE 12), Mackintosh's first contribution to 'The Magazine' in the Spring of 1894, is technically one of his most adventurous. It is a composition which is both naive yet calculated, free yet manipulated. The merest pencil outline delineates the eponymous cabbages and the fruit trees, though there is little if any scientific basis for their representation. The composition is seemingly random, yet, almost instinctively, Mackintosh has ordered a regular disposition of stalks and trunks across the sheet and balanced and counter-balanced the curves and slants of their outlines. The perilous technique of applying wet washes and drops of pigment has been skilfully controlled to contain colour within a balanced and harmonious scheme. Such a technique may well be indebted to the swagger 'blottesque' compositions of Glasgow Boy Arthur Melville. Mackintosh rarely repeated such

PLATE 12
CABBAGES IN AN ORCHARD, 1894
Pencil and watercolour

experiments, in which creative manipulation of the medium assumed greater significance than the drawing. Two extraordinary later watercolours, *'At the Edge of the Wood'* (PLATE 68) and *'A Yew Tree at Night'* (1913), however, show Mackintosh returning to this manner with even greater technical freedom.

■ ■ ■ Accompanying *'Cabbages'* in 'The Magazine' is a four-page explanation by Mackintosh of the subject, for the benefit of 'the ordinary ignorant reader'. In it he describes the rarity and endurance of his cabbages, 'a particularly hardy and long-suffering kind', and the extraordinary character of his orchard and its trees which 'are far away from any other trees, and I think they have forgotten what trees should be like.' He concludes with the advice that 'anything in the sketch you cannot call a tree or a cabbage – call a gooseberry bush. And also that this confusing and indefinite state of affairs is caused by the artist – (who is no common landscape painter, but is one who paints so much above the comprehension of the ordinary ignorant public, that his pictures need an accompanying descriptive explanation such as the above –). This may well have been Mackintosh's tongue-in-cheek riposte to Janet Aitken's schoolmistressly remarks on 'Originality', or it may have been prompted by Lucy Raeburn herself, directly or indirectly. In the previous number, Raeburn had confessed herself bemused by the Macdonalds' new work, describing herself as an ordinary person who preferred FACTS. In this context, the question is raised as to what extent the explanation, and even the title, post-date the creation of the work itself. The subject can be seen in another light. Cabbage patches were a staple subject for the Glasgow Boys' realist pictures, earning them the title the 'Kailyard [Cabbage Patch] School'. Mackintosh's whimsical alternative is perhaps jokingly directed at his painter friends.

■ ■ ■ Different concerns characterize a later contribution. In the November 1894 number, an untitled watercolour by Mackintosh presents what can be read as an

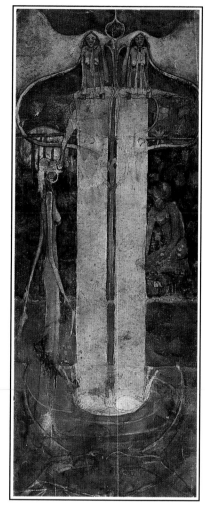

PLATE 14

ATTRIB. JAMES HERBERT McNAIR (1868–1955)

THE FOUNTAIN, *c.* 1893

Pencil and watercolour

THE COMPOSITION contains characteristic McNair imagery of hags, skulls, malevolent birds and weeping figures; but the meaning of the whole remains elusive. McNair is the conspicuous absentee from 'The Magazine', but this may have been due to his involvement in setting up as an independent designer after leaving Honeyman & Keppie *c.* 1894.

PLATE 13

STYLIZED PLANT FORM, *c.* 1894

Pencil and watercolour

IN THE MID 1890s Mackintosh explored the potential of plant forms as a source for symmetrical and abstracted decorative motifs.

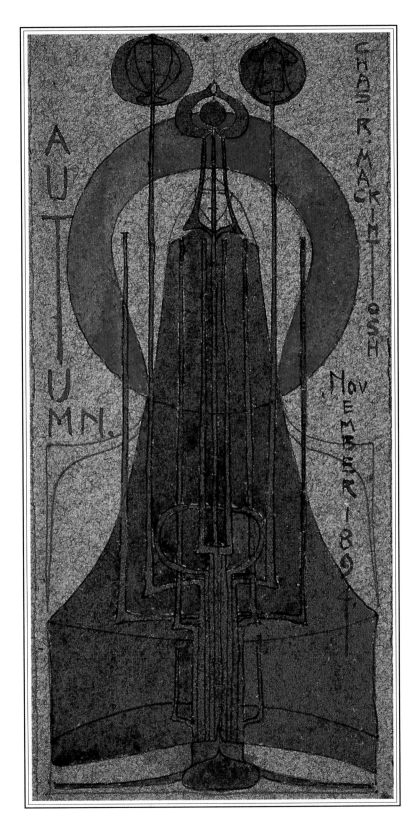

PLATE 15
AUTUMN, 1894
Pencil and watercolour

MACKINTOSH ILLUSTRATED Autumn, Winter and Spring for different numbers of Lucy Raeburn's album, 'The Magazine'. The seasons also provided the subject for an important collaborative set of watercolours by the Macdonald sisters (1897–8). These were worked in a more overtly romantic, fairytale idiom.

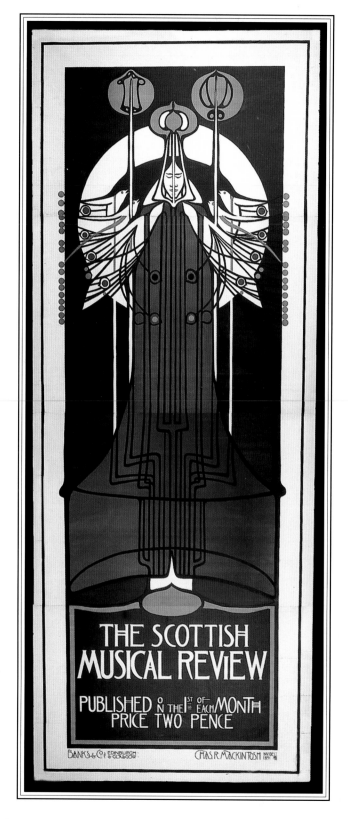

PLATE 16
'THE SCOTTISH MUSICAL REVIEW' POSTER, 1896
Colour lithograph

APPROPRIATELY, the design incorporates stylized songbirds, while the colour scheme of blue, purple-brown and green is evocative of the Scottish landscape.

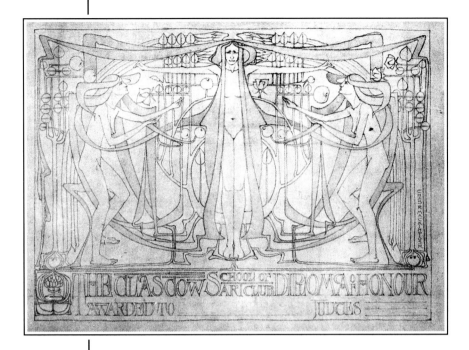

PLATE 20
DIPLOMA FOR THE
GLASGOW SCHOOL OF
ART CLUB, *c.* 1894
Photogravure

Symbolism did play a role. Traditional imagery – the apple as wisdom, the rose as love/art, the lily for purity – characterizes the few contemporary graphics – a diploma for the School of Art Club (PLATE 20), a programme for the Glasgow Architectural Association, a bookplate for John Keppie and a small group of posters. Only the *'Trees'* present a more complex plant symbolism. In them Mackintosh's abstracted forms have been used as metaphors for decay and corruption, for vitality and fertility. It is surely no coincidence that the sprouting stems in *'The Tree of Personal Effort'* can also be read as female reproductive organs.

■ ■ ■ The degree of Mackintosh's commitment to symbolism and its importance as a means of expression in his graphic work is difficult to document. No record exists of the books he owned, nor any evidence of an artistic collection. He gave no interviews. Little correspondence and only fragmentary memoirs survive. Some facts are known. Mackintosh, for example, read and shamelessly plagiarized the English Arts and Crafts architect W.R. Lethaby's heavily symbolic publication *Architecture, Mysticism and Myth* (1891). The striking images of the Japanese prints and reproductions of Pre-Raphaelite paintings that he hung on the walls of his studio-bedroom were infused with iconographic and literary references. The impact of Beardsley and Toorop's symbolic illustrations in the first volume of *The Studio* is well known, as is that of Carlos Schwabe's illustrations for Emile Zola's *Le Rêve*. But Mackintosh's interest in these illustrative works may have been as much motivated by their artistry as by their symbolic content. The masterful draughtsmanship of Beardsley, for example, presented him with an impressive and individual method of drawing –

PLATE 21
CARLOS SCHWABE (1866–1926)
'JE VOUS AIME . . .' FROM *LE RÊVE*, 1892
Lithograph

PLATE 20

THE DESIGN CAN BE READ as showing an apple tree (left) for wisdom and a rose tree (right) for art growing into a central tree of knowledge. As such it may have been intended to illustrate the artistic ambitions of the School's students, which are validated by the diploma.

allusive, refined, decorative and self-consciously exquisite. Mackintosh's architectural perspective drawings developed just such a character. The vertical format and delicate linearity of Schwabe's floral borders in *Le Rêve* were emulated in Mackintosh's sketchbooks. Mackintosh might even have referred to Schwabe's illustration *'Je vous aime . . .'* (PLATE 21) for a compositional framework for his *'Trees'*.

■ ■ ■ At the turn of the century, symbolism was a widespread artistic language throughout Europe. In the 1890s in Scotland it strikingly manifested itself in the painting, music and literature of the Edinburgh-based Celtic Revival, and in the decorative symbolic paintings of Glasgow Boys George Henry and E.A. Hornel. Notices of lectures and book reviews in the Glasgow press suggest a developing interest in the city in psychology and mystical eastern philosophies. Symbolism was the predominant expressive language of Mackintosh's immediate circle – the Macdonalds and McNair. Thomas Howarth, Mackintosh's principal biographer, records McNair explaining that not a line was drawn without purpose in his own work, and that rarely was a single motif employed that did not have some allegorical meaning. The aim was to realize the 'poetry of the idea'. But on the evidence of the graphic work itself, Mackintosh does not appear to have been as committed to the use of symbolism as his colleague, or the Macdonald sisters. None of his work approached, for example, the complex iconography of *The Fountain* (PLATE 14). Rather, his small group of 'Magazine' watercolours and related graphics constituted just one part of his wide-ranging experimentation of the 1890s, undertaken in the search for an individual language. These works were created almost entirely for the coterie of The Immortals and used the vocabulary developed by the Macdonalds and McNair, typified by Frances Macdonald's early frontispiece. The deeply felt personal content of the *'Trees'* led Mackintosh towards a more expressive plant symbolism than that of any of The Immortals; but he did not take the possibilities further.

■ ■ ■ One major work stands outside this group – the early *'The Harvest Moon'* (PLATE 9). Its iconography is not certain, but the juxtaposition of a winged angel-like figure and a stream of voluptuous nudes hidden in the cloud suggests the subject may have been opposing themes of chastity and abandon, Christianity and paganism, the old order and the new. The picture's decorative finish and the overtones of a moral parable link it, as another experiment, to the early work of Henry and Hornel.

■ ■ ■ Stylized plants play a significant role in *'The Harvest Moon'*. Compositionally, the close-knit pattern created with the plants counters the void of the night sky above. Despite its apparent density, twigs, thorns and berries are woven into a flat pattern which sits like a spider's web at the front edge of the picture. Though the plants cannot be securely identified, the subject of ripe fruit reinforces the title's autumnal theme. The jagged bush may also play a symbolic role – the thorns protect the fruit while the bush itself stands between the viewer and the central figures. This guardian role may provide a commentary on the relationship between the winged and nude figures.

■ ■ ■ The combination of symbolic imagery with decorative stylization in Mackintosh's painting appears to have ceased with the last issue of 'The Magazine' in 1896. Hostile critical reaction to its public face, the related poster designs, may have contributed to this decision, and there is a clear shift with the watercolours of 1896 to 1899 to a more conventionally decorative and thematically acceptable subject matter. This new work was widely exhibited in Glasgow, London, Venice and Vienna. *In Fairyland* (PLATE 22), *In Poppyland*, *Fairies*, *'Princess Ess'*, *'Princess Uty'* and others are closer in fact in subject and mood to the literary content of 'The Magazine'. With its demise, the stimulus to devise new images in a symbolic idiom no longer existed. Mackintosh, after all, had other challenges by then: a new building for the School of Art, and decorations for Miss Cranston's Buchanan Street Tea Rooms – with other commissions to follow in rapid succession. Symbolic imagery was not abandoned. The early graphic experiments of the mid 1890s flowered with Mackintosh's growing autonomy and assurance as a designer in the larger scale of a suite of Tea Rooms, a School of Art building, or the interiors of his and Margaret Macdonald's marital home. From 1896, by contrast, his watercolours were to focus increasingly on the observed reality of landscape, architecture and plant forms.

A BOTANICAL ARTIST

'In nature you may go mad over some great landscape but neverthe-
less every tree – aye every leaf – every blade of grass and even "every
wee modest crimson tipped flower" demands and I hope receives its
share of admiration.'

C.R. Mackintosh, 'Architecture', 1893

ACKINTOSH'S EARLY INTEREST IN PLANT DRAWING CONTINUED THROUGHOUT HIS LIFE.
The work from 1900 until 1915 can be divided into two disparate
periods. First, an extended stretch until 1914 during which only a few
drawings were made. Sketching had by then largely become a leisure
activity carried out on rare trips away from Glasgow. Second, an
intensely productive phase from 1914 to 1915 when an extended visit
to Walberswick in Suffolk provided an opportunity to paint without distraction. The
watercolours produced there drew on the accumulated experience of the previous years
and constitutes Mackintosh's finest work as a botanical artist.

■ ■ ■ A gradual evolution in technique is apparent. Initially the linear style of
drawings such as *'Evening Primrose'* and *'Foxglove, Ascog'* was continued. But in
1901 there was a brief but marked increase in output, and a number of significant
stylistic changes were introduced. The catalyst would appear to have been Mackintosh's
marriage in August 1900 to Margaret Macdonald. This led to more settled holidays,
rather than Mackintosh's usual frenetic bachelor trips, and created more sustained
opportunities for flower painting. In July of 1901 the couple travelled to historic Holy
Island, picturesquely set off the Northumberland coast. This small community was to
become a favourite location and at least three return visits were made, in 1902, 1906
and 1913. Its seclusion, artistic connections and coastal location were to be typical of
later retreats at Walberswick and Port Vendres in France. Eleven flower studies from
the 1901 trip are documented. Greater leisure allowed for more developed presenta-
tion. In *Stork's-bill* (PLATE 23) we see one of Mackintosh's earliest applications of
watercolour. Pure wash is selectively applied both to record the plant's colouring, and
to heighten the decorative quality of the whole, in a manner similar to that used for
Mackintosh's contemporaneous furniture designs. This drawing includes another new
element – a cartouche box – to contain Mackintosh's inscriptions of place and date,
and the initials of those with him at the time of the drawing. Here 'MTFBC' for

M ACKINTOSH has concentrated on a skilful arrangement of the flowers and fruits. The umbellate inflorescence and long-
beaked fruits suggest a stork's-bill (*Erodium*). However, the lack of leaves impedes identification. On grounds of
geographical distribution, the only likely species is common stork's-bill (*Erodium cicutarium*).

Margaret, Toshie (Mackintosh himself), Frances and Bertie (James Herbert) McNair who had married in 1899, and Charles Macdonald, Mackintosh's brother-in-law. Thereafter Mackintosh became meticulous about signing, dating and locating the flower studies – a habit he did not apply to the later still-life and landscape paintings. In the drawings of the 1890s, initials had been integrated into the main subject or scattered, seemingly randomly, across the sheet. Those that can be identified are initials of friends or place names.

■ ■ ■ The introduction of the cartouche box provided a simple means of containing both this information and the date. Its use derived from Japanese prints, and further testifies to Mackintosh's continuing preoccupation with lettering and the presentation of his signature. The graphics of the 1890s had seen many experiments with cursive, vertical, abbreviated and arbitrarily broken texts and signatures. The simple form of the inscribed box well suited the format of the flower drawings, and subsequently varied little, though in later studies it was incorporated with greater sophistication as an integral part of the overall composition.

■ ■ ■ The advances established with the Holy Island watercolours were developed over the next decade on Mackintosh's occasional trips in England, to the Scilly Isles, and to Portugal. But with the exception of the productive 1910 visit to Chiddingstone, less than a dozen works survive from this period.

■ ■ ■ 'Spurge' (PLATE 24) well illustrates the increasing complexity of Mackintosh's compositions. The Mackintoshes visited East Sussex in the early summer of 1909, where Mackintosh sketched the domestic vernacular architecture of Groombridge and painted a few flower studies at Withyham, near Tunbridge Wells. The subject of 'Spurge' is more elaborate than many of the earlier works, being a composite of three plants: a periwinkle at the top, spurge in the centre and two rhododendron flowers to the right. Greater sophistication is also shown in the composition. Its framework is a complex web of outlines that overlap and intertwine, denying the three-dimensionality

T OP LEFT IS A PERIWINKLE, probably greater periwinkle (*Vinca major*). It is not clear which species of the cultivate perennial spurge (*Euphorbia*) is shown. To the right are two flowers of a rhododendron, of which many species and hybrids are in cultivation.

and opacity of the subjects. The whole is clarified by more extensively applied watercolour washes.

■ ■ ■ In the spring of the following year, the Mackintoshes holidayed in the Kentish Weald, visiting Leigh, Hever and Cowden. It was Chiddingstone, however, which attracted most attention and became a favourite location. At least one other visit, for Christmas 1920, is recorded. In the spring of 1910, Mackintosh was beguiled by its show of flowers; eleven exquisite drawings of them survive.

■ ■ ■ The Chiddingstone flowers are among Mackintosh's finest, displaying great purity of handling. With *'Japonica'* (PLATE 25), Mackintosh concentrates on the shrub's vivid scarlet flowers. Here again areas are left deliberately clear of watercolour, while the densely packed stamens and bursts of bright pigment punctuate the overall composition. With *'Cuckoo Flower'* (PLATE 26), Mackintosh's intention is different, to illustrate the structure of the plant showing stem, leaf and flower. But, ever the architect, he gives to the right, an aerial view of the plant in plan, and, ever wilful, incorporates two flowers of an unrelated and unidentified plant.

■ ■ ■ Mackintosh would regularly draw the local architecture as well as the flowers. His sketches of Chiddingstone are among the most elaborate, recording the village's remarkably complete sixteenth- and seventeenth-century half-timbered architecture, and the distinctive Kentish oasthouses, the odd, inverted-cone shaped buildings that housed drying kilns for hops and malt. Usually the different subjects were worked up separately, but occasionally the two were merged, as in the earlier *Sea Pink, Holy Island* (PLATE 27). In that watercolour one detail, a clump of sea pink, is isolated and enlarged against a broader background, a raking view of the battered fortifications of Holy Island castle. Other studies, from the same visit, of the thirteenth-century church of St Mary make more daring overlays of plant forms against the architecture. Mackintosh did not distinguish stylistically between the two subjects. A church, a cottage oven, a sprig of blackthorn would be examined with equal rigour and its forms crafted into a composition. Plant studies and architectural sketches could each present a general view of the main subject, enriched with elaborations of specific details, and the occasional incorporation of other extraneous but decorative motifs.

■ ■ ■ Little painting was done in the four years after the Chiddingstone visit, apart from a couple of flower studies at Bowling, near Glasgow, and Holy Island. However, in 1914, in the hiatus caused by major upheavals in Mackintosh's professional life, the opportunity emerged to concentrate on drawing and painting to a degree not matched since the trip to Italy over twenty years before.

■ ■ ■ By 1913, the architectural partnership of Honeyman, Keppie & Mackintosh, formed in 1901, had reached crisis point. Little new work had been brought in by Mackintosh since the completion of Glasgow School of Art in 1909, and he was reputedly increasingly depressed and dependent on alcohol. The partnership was formally dissolved in 1913. Mackintosh's attempts to set up on his own failed, and, in the summer of 1914, the Mackintoshes withdrew to Walberswick on the Suffolk coast for a recuperative holiday. Their plans were disrupted by the outbreak of war shortly after their arrival. Margaret Macdonald later recalled in a letter to a friend, Anna Geddes, wife of the Scottish sociologist and planner Patrick Geddes, '[we planned] coming just for a holiday & then war broke out & I induced Toshie to just stop on & get the real rest-cure that he so badly needed for quite two years – it struck me as the right thing to do – there will be nothing really doing till the war is over for one thing & for another it is too dangerous to go on – when a man is over-worked he must rest or something serious will happen – so it was all arranged and I went back to Glasgow & let the house furnished for a year . . . & we are going to have a real WanderJahr – already Toshie is quite a different being & evidently at the turn of the year will be quite fit again & by that time we hope the war will be over & then perhaps he can have a hand in rebuilding the beautiful cities which are lost to us.'[1]

■ ■ ■ Rural Walberswick provided an ideal escape from the city. A tiny community of some 370 inhabitants, its buildings straggled picturesquely on either side of The Street and round the village green. Sited on the banks of the sluggish river Blyth, it offered spectacular sea views and pastoral country settings, as well as the diversity of the local fishing industry. Larger and more prosperous Southwold was a short walk, or a brief ferry journey, away.

■ ■ ■ A more specific draw for the Mackintoshes would have been the presence of Francis and Jessie Newbery. According to their daughter, Mary Newbery Sturrock,

Newbery first visited Walberswick in the 1880s with the painter Philip Wilson Steer, and he returned regularly thereafter, buying a house, Rooftree, in the early 1900s. It is more than likely that the Mackintoshes had holidayed there with the Newberys before 1914. Certainly Mackintosh knew the surrounding area, having sketched at Southwold, Halesworth and Blythburgh (and probably Walberswick) on a much earlier trip in 1897.

■ ■ ■ The beauties of Walberswick had attracted artists since the early nineteenth century. In 1880 it received the ultimate accolade, a satirical mention in *Punch*, with 'A Warble of Walberswick':

> *There's no horrible cheap tripper comes, a most persistent dipper*
> *In the 'briny', and Cook's tourist is unknown within these parts;*
> *And the sunset waxing fainter o'er the church delights the painter,*
> *No wonder then that Walberswick is dear to artists' hearts.*

Among the many artists drawn to Walberswick at the end of the century were Frederick Brown, Roger Fry, Sidney Starr, Edward Stott and Walter Sickert. By 1914, however, the village was quiet; many artists were involved in war work, and the only painters with whom Mackintosh is known to have associated, in addition to Newbery and his daughter, were the Glasgow Boy E.A. Walton, at nearby Wenhaston, and the landscape painter Bertram Priestman.

■ ■ ■ The supportive Newberys arranged lodgings for the Mackintoshes in the adjoining house to theirs, and found them a converted fisherman's hut as a riverside studio. The Mackintoshes devoted the next twelve months to painting. In the few surviving landscapes, Mackintosh is preoccupied not with the rural sweep, nor with the grand effects of sea or sky, but with the architecture and engineering of the river's jetties and harbours. What clearly intrigued him was the relationship between man-made and natural forms. His main efforts, however, were focused on flower painting, to the virtual exclusion of architectural sketches.

■ ■ ■ According to the recollections of the couple's close friend, Desmond Chapman-Huston — published in the periodical *Artwork* in 1930 — there was the possibility of

exhibiting or publishing the flower studies on the Continent. This incentive would explain Mackintosh's dramatically increased output – over forty drawings within twelve months. Though these plans must have been jeopardized by the outbreak of war, Mackintosh was undeterred, and probably shared the general early optimism that the war would soon be over. In any case, the distraction of flower painting must have soothed his exhausted state of mind. Some watercolours were finished in 1914, but the greater number were worked on in the spring and early summer of the following year.

■ ■ ■ Undoubtedly the majority were drawn from freshly picked specimens, though, from an inscription on a drawing of the mid 1890s, Mackintosh is known to have worked from pressed flowers. According to contemporaries' recollections, Mackintosh worked largely indoors in the studio he shared with Margaret. Almost two-thirds of the documented Walberswick flower studies record cultivated plants – the herbaceous perennials, bushes and trees of gardens. The remainder are wild plants, for the greater part commonly encountered ones.

■ ■ ■ The Walberswick watercolours have an overall stylistic consistency. Each generally shows a single species; each is generally worked to the margins of the sheet. The drawing relies exclusively on pencil outline with no hatching or modelling. Subsequent washes of pure watercolour express and modulate form. But there are diversities. Mackintosh's subjects range from flowering shrubs such as jasmine to herbs like borage and sorrel, from large-petalled blooms such as petunia (PLATE 28) to diverse evergreens such as rosemary and Scots pine. Each allows the exploration of different aspects of plant forms: the interlocking network of gorse thorns and leaves (PLATE 29); the spider-shaped flowers of Japanese witch hazel (PLATE 30); the silky tissue of a petunia's petals. If Mackintosh was working to a specific programme, self-imposed or otherwise, it was a broad one, embracing a wide variety of plants found in Britain, and exploring both flowers and foliage for decorative effect.

■ ■ ■ Mackintosh could subtly diversify his presentation to suit the characteristics of his subject. In 'Anemone and Pasque' (PLATE 31), the complexity of the splayed and feathered leaves is developed as a central element. A leaf is displayed, fanned out, filling almost one third of the composition. Its form is enriched by the use of tonal variations in the wash and by selectively sponging the watercolour to modulate the

paint surface. By overlaying the outlines of stem and leaf, Mackintosh creates additional decorative effects and ambiguous spatial relationships between the respective components. The petals of the *Anemone coronaria*, for example, are modelled with thin and at times layered washes of grey, violet and blue pigment. These have then been sponged to blend the colours and create highlights. Finally, the resultant tonal subtleties are offset by selected touches of denser pigment.

■ ■ ■ By contrast, the slender stems, thin tapered leaves and chequered petals of the fritillaria (PLATE 2) presented different decorative qualities. Mackintosh emphasizes not the structure, but the graceful movement defined by leaves and stems as they stretch and turn and overlap and touch. Their elegant outlines are carefully infilled with barely modulated wash. Mackintosh does not record the full tonal complexities of the flower head, but simplifies these in order to focus on the petals' unique dived pattern, a motif which is extended into the cartouche box.

■ ■ ■ In many of the flower drawings, the dominance of the ...ie, the lack of tonal modelling and the layering of leaf and petaly the three-dimensionality of the original subject. Mackintosh's co- ... was to create decorative surface patterns in which the space between ... uifferent elements of the subject becomes as significant as the outlined forms. This is vividly illustrated in *'Fritillaria'*. However, here, having moulded his subject into an exquisite flat pattern, Mackintosh contradicts this by peeling forward the petals of one flower to reveal, behind its demure exterior, the vividly coloured reproductive parts, and the flashes of yellow at the inner tip of each petal.

■ ■ ■ Mackintosh rarely returned to this format after leaving Walberswick in 1915: two studies from Chelsea, one from Buxted, Sussex, and a small group dated 1924 and 1925 from the final years in France, are all that are known (PLATE 51).

■ ■ ■ Stylistically, Mackintosh's botanical studies are closely related to certain aspects of Japanese painting. These had been characterized in an early *Studio* article discussing Japanese drawing technique, in which the author could as easily have been describing Mackintosh's work: 'Simplicity and reticence are apparent in all the best specimens of Japanese art. No redundant lines are allowed to interfere with the desired result, while the appearance of relief is conveyed by subtle drawing rather than by light

and shade.'[2] In addition to refined draughtsmanship, both were concerned with the careful disposition of the subject on the sheet and the decorative integration of any text.

■ ■ ■ Japanese art would have been familiar to Mackintosh through a variety of sources, in particular publications and exhibitions. The early issues of *The Studio*, for example, again played a crucial role. Volume one contained an article on 'Artistic Japanese Gardens' by its enthusiastic and knowledgeable proprietor, Charles Holme. Other articles on subjects such as flower arranging, stencilling, wood carving and metalwork appeared regularly in subsequent volumes. The School of Art Library had a collection of Japanese publications. More immediate were the first-hand accounts of Mackintosh's contemporaries, the Glasgow painters George Henry and E.A. Hornel, who had lived in Japan from 1893 to 1895. In February of 1895, Hornel prepared a lively lecture on his experiences to be delivered at the Corporation Art Galleries. It is probable Mackintosh attended, or certainly knew of it, as the lecture was read on the night by Hornel's close friend, John Keppie, due to the author's indisposition.[3]

■ ■ ■ A recurrent theme in all of the accounts, and one which would have resonated with Mackintosh, was the reverence of the East for nature, and the degree to which plant forms formed an integral part of daily life. Hornel recalled: 'This reverence for everything in nature finds its truest expression in their passion for flowers, especially those of the cherry, and gives us an insight into their true character. The poet Motoori writes – "If one enquires of you concerning the spirit of a true Japanese, point to the wild cherry shining in the sun."' As Hornel observed, art and nature were both so deeply embedded in Japanese culture that their vocabulary seemed to contain no words to express these concepts separately. That Mackintosh admired Japanese art is demonstrated by the inclusion in his home, and earlier in his studio-bedroom, of oriental ceramics and woodblock prints – among the very few decorative items he tolerated which were not to his own design (SEE PLATE 66).

BASKETS
OF FLOWERS

'I was wondering if you could see your way to buy one of my flower pictures or landscapes for £20 or £30 . . . my rent of £16 is overdue and I must pay or leave.'

C.R. Mackintosh to William Davidson, April 1919

N JUNE OF 1915, THE WALBERSWICK IDYLL WAS ABRUPTLY ENDED. AS AN OFTEN SOLITARY and foreign-sounding figure, constantly sketching in this invasion-anxious area, Mackintosh had aroused local suspicions that he was a spy. In June he was ordered to leave the district and, despite protestations, was banned by a military order at the beginning of July from staying in the counties of Norfolk, Suffolk and Cambridge. Outraged, Mackintosh sped to London to clear his name of what he described indignantly to a friend as a 'horrible imputation' and an 'absurd outrage on the rights of perfectly loyal subjects'.[1] A resolution was not immediately forthcoming, and in the capital Mackintosh was for some weeks trailed by two detectives. It took three months of representations to the Home Office to have the order suspended.

■■■ By the beginning of August, he had been joined by Margaret, whose arrival had been delayed by ill-health. Though the move to the capital had been unplanned, it extended into an eight-year stay. Few realistic alternatives existed in the war-bound economy and the Mackintoshes must have recognized the financial necessity of staying in an urban centre to secure desperately needed work; a return to Glasgow does not appear to have been considered.

■■■ Lodgings were quickly found at Paulton's Square, Chelsea, in the summer of 1915, with adjoining studios in nearby Glebe Place. Chelsea's artistic community, at once part of but distinct from the metropolis, provided another peaceful haven. The couple became involved in a variety of activities, both dramatic and artistic. Their Scottish friend Margaret Morris made them honorary members of her Theatre Club in nearby Flood Street. They became active set-painting and costume-making members of 'The Plough', a private theatrical group officially founded in 1917 and based in Millais House, home of the photographer E.O. Hoppé. Mackintosh became involved, probably through Margaret Morris's partner, the painter J.D. Fergusson, with the reorganization after the war of the London Salon of Independents and the establishment of the Arts League of Service, a charitable scheme for impoverished artists.

■■■ Commissions were less readily forthcoming. Mackintosh was little known in the capital, and his life-long reluctance to tout for work persisted. What jobs did come in were in large part initiated by his Chelsea circle: a theatre, unexecuted, for Margaret

Morris; minor extensions to Hoppé's country house and their Glebe Place neighbour J. Stewart Hill's studio; three artist's studios (only one of which was built) and two ambitious but unrealized studio blocks for the Arts League of Service, all on a contiguous site in Glebe Place. But all of this came in 1920 and the majority of it did not proceed beyond the drawing board. With the exceptions of the remodelling of 78 Derngate, Northampton, and related designs for its client W.J. Bassett-Lowke and his friends, and the Dug-Out interior for Catherine Cranston's Willow Tea Rooms in Glasgow, no architectural or interior design work was completed between 1915 and 1919 or after 1920. To ease their parlous financial situation, Mackintosh turned to commercial textile design, and to painting.

■ ■ ■ Mackintosh's painterly ambitions had been stimulated in Walberswick, and continued to grow in London. There his circle included the distinctive talents of old friends James Pryde and J.D. Fergusson, and new friends Randolph Schwabe, Rudolph Ihlee and Edgar Hereford. The joint ambition of the Mackintoshes to establish themselves quickly in London as painters is seen in their exhibit for the 11th Arts and Crafts Exhibition which ran from October to November 1916. The couple's installation comprised a wall decoration of a painted panel and candlesticks titled 'The Voices of the Wood' (PLATE 35). However, the exhibit did not bring the success they must have hoped for, receiving few critical notices. Perhaps its composition, based on gesso panel designs by Margaret Macdonald of 1903, and an esoteric programme of dirges, laments and lost souls, appeared outmoded. None the less the venture underlines Mackintosh's changing self-definition from designer to painter, and contains one of his earliest experiments in London with stylized floral patterns. The couple continued to work on a large scale. In August 1919, Mackintosh wrote to William Davidson that they were working together on another six-foot (two-metre) square panel (untraced) for a forthcoming Arts League of Service exhibition.

■ ■ ■ Concurrently Mackintosh was working independently on a smaller scale, in watercolour, producing exquisitely draughted and coloured still-life compositions. Still-life painting was an obvious development from the Walberswick work. Mackintosh appears to have preferred to work from life, and subjects were readily available in the city's flower shops and Chelsea gardens. Mackintosh's growing ambition as a

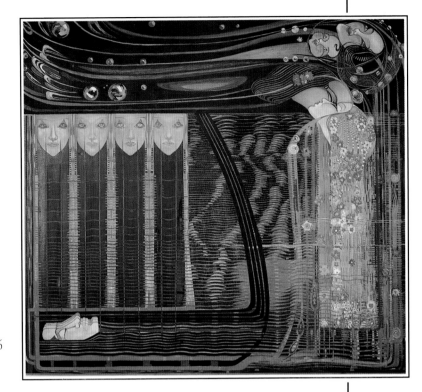

PLATE 35
MARGARET MACDONALD
MACKINTOSH
(1864–1933) WITH
CHARLES RENNIE MACKINTOSH
THE OPERA OF THE SEA, *c.* 1916
Oil and tempera on canvas
with *papier collé*

T HE SURVIVING RIGHT-HAND PANEL of *'The Voices of the Wood'*. The other panel, based on Margaret Macdonald's gesso *'The Opera of the Winds'*, is untraced. Drawings in Mackintosh's hand for the female figure's flower-decked hair suggest his involvement in the decorative detailing.

painter, coupled with the need to make money by exhibiting and selling, must have encouraged the development of more elaborate compositions rather than continuing with botanical studies. The demands of these more sophisticated compositions, however, took their toll on his productivity and Mackintosh worked painstakingly. Only ten watercolours from 1916 to the early 1920s are documented. Although few are dated, a chronology can be established by using known exhibition dates as a likely completion date – presuming Mackintosh chose to show current work and that all of the pictures were completed before the couple's departure for France in 1923: *'Anemones'*, *'Petunias'* and *'Begonias'* (1916); *'White Roses'* (1920); *'Pinks'*, *'Grey Iris'* and *'Yellow Tulips'* (1923). The remainder can be incorporated on grounds of composition, style and content: *Cyclamen* alongside *'Anemones'*, *'Petunias'* and *'Begonias'*; and *Peonies* and *White Tulips* with the final group. Mackintosh's subjects range from a single iris to a mass of carnations: but never a mixed bouquet. He rarely chose variegated blooms or blooms of different hues. *'Anemones'* (PLATE 34), with its scheme of blues, reds and whites, is the most diverse he allowed. Mackintosh clearly preferred the formal purity of a single type. Within this self-imposed restriction,

Mackintosh ranges from the elaborate flowers of anemones, petunias, begonias, roses and carnations, with their complex petal structures and tonal riches, to the more linear form of a cyclamen, tulip or iris.

■ ■ ■　Mackintosh's selection of props was as restrained as his choice of flower. He did not use draperies, a standard device in flower paintings for backdrops or coverings, preferring either a neutral background, or a flat, patterned backdrop to his own design. In 'Petunias' (PLATE 36) it would appear that he even used one of his designs on paper for a textile as a backdrop. In those compositions where Mackintosh's own patterns have been used as a backdrop, the relationship is perhaps more than that of decoration around the principal subject. Arguably in 'Petunias' and in Cyclamen (PLATE 37), Mackintosh is showing the primary source from which he abstracted the resultant pattern. Similarly, but with even greater abstraction, the background designs in Peonies and 'White Roses' can be seen as expressing the distinctive outline of each specimen's petals and the interstices between them. Such rhythms were more fully developed in the textile designs (SEE PLATE 48).

■ ■ ■　The occasional supporting object is introduced. In Cyclamen, the little pig passes virtually unnoticed, but in 'The Grey Iris' (PLATE 38) the jug and bowl are more significant, their richness countering and reinforcing the austerity of the main subject. The jug, an ordinary Mason's Ironstone piece, appears aesthetically an uncharacteristic item for the Mackintoshes to have owned or for Mackintosh to have chosen to paint. But clearly it was a cherished item, for it had accompanied them from Glasgow; it (or a duplicate) is shown in early views of their Glasgow flat at 120 Mains Street. Generally the flower containers are formally simple and unobtrusive. Vases of a similar type appear in Peonies, White Tulips and 'Yellow Tulips'. With later works, such as 'The Grey Iris', Mackintosh became increasingly intrigued with the decorative potential of reflections, and vases and tabletops with more reflective surfaces were used.

■ ■ ■　In the majority of the watercolours, the compositions are set in shallow space, often with strong lighting from the right, and a clear distinction made between tabletop and backdrop. In two of the later watercolours, a greater sense of depth is developed. Both are studies of leggy tulips, which perhaps required more developed backgrounds to enrich the overall compositions. In White Tulips we are given a table

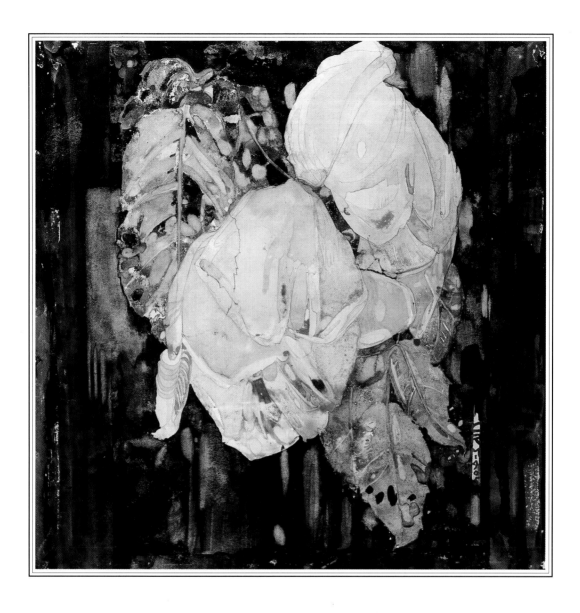

PLATE 41
FADED ROSES, 1905
Pencil and watercolour

I<small>N</small> 1923, before he left for France, Mackintosh gave this watercolour to the wife of his friend, the designer George Sheringham (1884–1937). His signature and the date are concealed in the light vertical strip to the right of the lower cluster of leaves.

■ ■ ■ Tragically, Mackintosh's first concerted attempt to succeed as a professional painter failed. He exhibited at the Goupil, with the Arts League of Service and, at least initially, with the International Society of Sculptors, Painters and Gravers. He also exhibited in America, at Detroit in 1920, and each year from 1922 to 1925 with Chicago's newly inaugurated annual International Water Color Exhibition. With the sole exception of *'Petunias'*, purchased by the Detroit Art Institute, none of his exhibits found buyers. In desperate straits, Mackintosh was forced to write to William Davidson on several occasions seeking financial help. It was Davidson who in 1915 had unhesitatingly supplied the money which enabled Mackintosh to come to London from Walberswick. Four years later Mackintosh's plight was still serious. In April 1919 he wrote: 'I am writing to you on a very curious matter. Frankly I find myself at the moment very hard up and I was wondering if you could see your way to buy one of my flower pictures or landscapes for £20 or £30 or could you take it in pawn for 2 to 3 months . . . we have had a hard struggle during the last 3 years of the war as no architectural work was possible . . . If you can see your way to help me out of a serious difficulty I shall be further in your debt. I shall be glad to hear from you this week as my rent of £16 is overdue and I must pay or leave.'[4] Davidson proved himself, again, a supportive friend. In response to this plea, he bought *'Begonias'* for £30 and, over the next months, provided a further £7 for a tax bill and £20 for rent.

■ ■ ■ Mackintosh's other, more lucrative activity was commercial design for printed textiles. With the exception of the early furniture designed in the 1890s for the Glasgow firm of Guthrie & Wells, Mackintosh had no experience of speculative design. Nor had he experience of printed fabric design; his Glasgow textiles had been confined to stencilled or embroidered pieces. However, it was not unusual for artists and designers at this time to work as freelance textile designers. A significant number of Mackintosh's friends and associates worked in this way, including George Sheringham, Claude Lovat Fraser, E.O. Hoppé, Harold Squire, Rudolph Ihlee, E. McKnight Kauffer

THE TULIP is the commonly attributed source for this design, but the plant is so abstracted that it could as easily be referenced to honesty or a closed flower bud. Mackintosh explored this theme in a number of designs, experimenting with other variations in detailing and colour schemes.

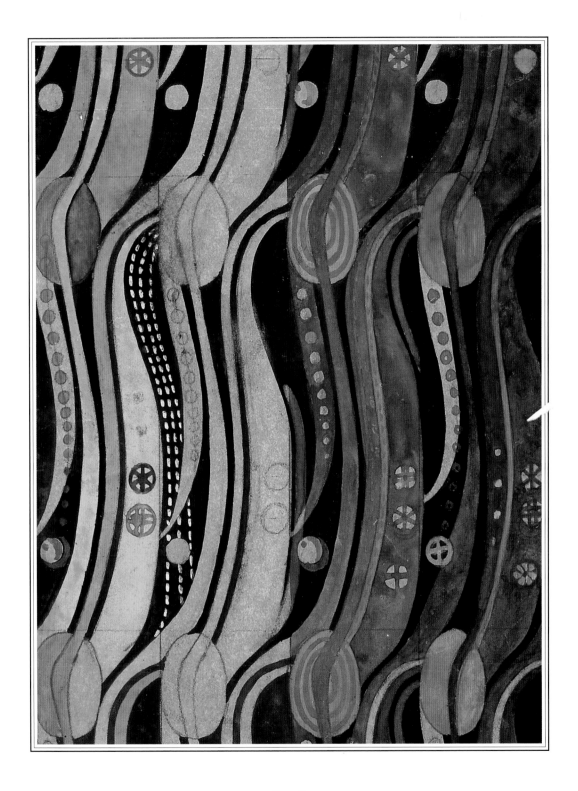

PLATE 42
TEXTILE DESIGN: STYLIZED TULIPS, 1915–23
Pencil and watercolour on brown tracing paper

71

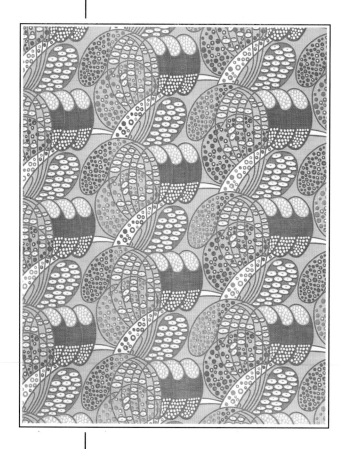

and Randolph Schwabe. Encouragement and introductions may well have come from within this group. Such diversity of activity was in part indicative of the artists' financial need, but also indicative of manufacturers' more progressive attitudes to design in the post-war period. The industry had been stimulated by the experimental cross-over between painting and design initiated by the Omega Workshops from 1913 to 1919, and by the need to pull out of the post-war slump. Other of Mackintosh's architect-designer contemporaries, notably George Walton and C.F.A. Voysey, increasingly depended on textile design in the absence of other work after the war. But few responded with Mackintosh's flair and creativity, producing designs that placed him at the forefront of British avant-garde textile design.

■ ■ ■　Some 120 designs and a few original samples survive.[5] These amply testify to Mackintosh's versatility in producing patterns for roller and block prints, for voiles, silks and cretonnes, furniture fabrics, curtains and handkerchiefs. The majority of the designs comprise preliminary workings of ideas with little indication of final material, scale or colourway. *Tulips* (PLATE 42) is a typical example, showing four identical repeats of a stylized flower, stem and leaf, but each shows different variations in detailing and colour; see, for example, the different treatments of the flower head. Not

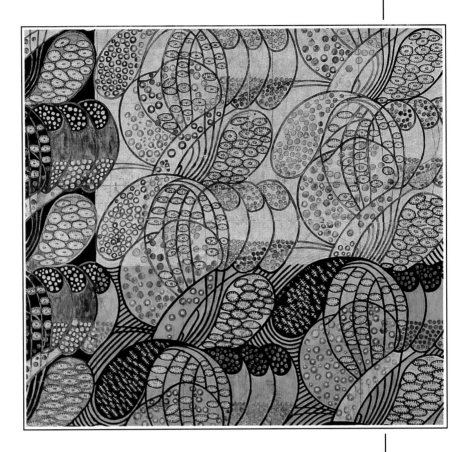

that a 'finished' design fully detailed by the artist was a guarantee that the pattern would be faithfully reproduced by the manufacturer. Dictates of technology, budget, market demand or house style could result in substantial changes to the original proposal. The colourway of Mackintosh's daisy pattern was significantly changed between design and production (PLATES 44 and 43).

■ ■ ■ Mackintosh took up textile design soon after his arrival in London and appears to have kept it up throughout the years in Chelsea. The earliest documented design appears in the background to 'Anemones' of 1916 and the last documented, two voiles, were published in *The Studio Year-Book of Decorative Art* of 1922. But it is virtually impossible to establish a secure chronology for the vast majority, as Mackintosh did not date his designs. There is some other evidence, at least for 'executed by' dates: those others used as backdrops to the still lifes as in 'Petunias', and those published in *The Studio Year-Book of Decorative Art* for 1917 and 1918. In addition, Mackintosh used his fabrics in a number of his interior schemes: the hall at 78 Derngate, Northampton (1917) and the dining room of Candida Cottage, Roade, Northampton (1918), both for W.J. Bassett-Lowke; and a bedroom for Sidney Horstmann, Weston Road, Bath (1917). These interiors show that at least three stylized organic

patterns were in production between 1917 and 1918. Mackintosh used the fabric for curtaining, and, stretched flat, as decorative panels for a washstand splashback and a wall covering. Used in this way, the textiles provided a substitute for the leaded glass and stencilled decoration of Mackintosh's Glasgow interiors.

■ ■ ■ Designs were sold in London to Liberty & Company Ltd and to William Foxton; to Sefton & Company, Belfast; Templeton's of Glasgow; and probably F.W. Grafton's, Manchester. They provided valuable income. Mackintosh received between six and ten guineas for each, in 1920 earning almost £200. Foxton was the major purchaser. As an exhibitor and speaker at the 1916 Arts and Crafts exhibition, it is conceivable that Foxton first became aware of Mackintosh's pattern-making skills through 'The Voices of the Wood' (PLATE 35). Foxton was to become one of the most innovative British textile manufacturers. His forthright views on design were laid down in one of the discussion events accompanying the 1916 exhibition: 'This trade in things of antique appearance is detrimental to modern development and progress and against the best interest of industrial prosperity. If the public taste could be directed towards well-made modern things, it would encourage craftsmanship and stimulate a greater individuality in work.'[6] It was a vision after Mackintosh's heart. Foxton wanted freedom, individuality, 'simpler forms of design and display of colour'. It was a brave statement, as many of the textiles on display were 'after old examples'. That he succeeded in his ambitions was later praised by the architect and designer W.G. Paulson Townsend in his volume on *Modern Decorative Art in England* (1922). The work of Foxton's designers, including Mackintosh, Rex Silver, Constance Irving, Minnie McLeish and Lovat Fraser gave 'that feeling of sunshine and fresh air so desired by the modern mind . . . liberated some designers from the stereotyped imitation of historic style' and by 'finding scope for a free exercise of their talents contributed immensely to the success of the modern tendencies.'

■ ■ ■ Though Mackintosh had little experience as a textile designer, he was a consummate pattern-maker. The Glasgow interiors and architecture had been enriched with ornament in a variety of media. The Hill House stencil (PLATE 45) typifies his skilful integration of organic and geometric motifs. These sources were to provide the basis for the London textiles.

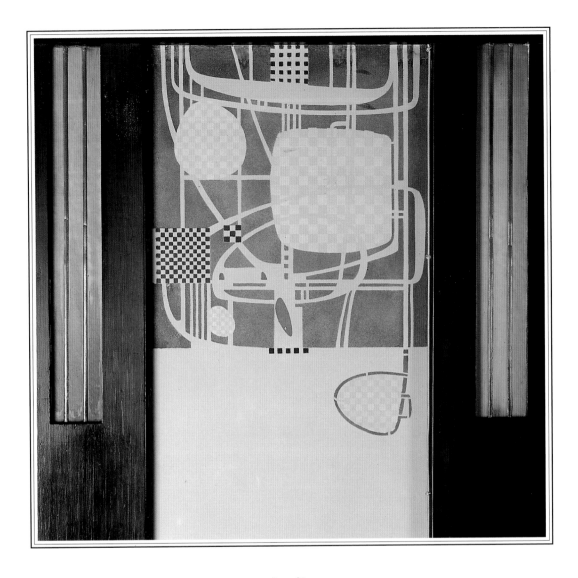

PLATE 45
HALL STENCIL, THE HILL HOUSE, HELENSBURGH, 1903
Painted plaster

THE WALLS OF THE long hall at The Hill House were divided horizontally by a picture rail. Stained wood panels, set with vertical strips of pink leaded glass, were fixed below this at regular intervals. A low frieze was created round the room by decorating the upper section of the wall framed by the panelling with this complex stencil design.

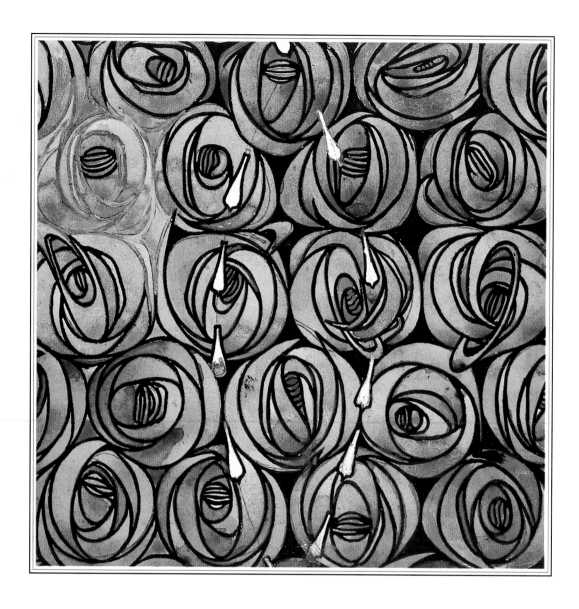

THIS PATTERN HAD FIRST been developed much earlier as an alternative proposal for the background of a plaster panel frieze for the Willow Tea Rooms, Glasgow (Plate 61). In London it was reworked as a textile design in this pink colourway and, in a closely related drawing, it is shown in both blue and grey with a variant background.

■ ■ ■ The vast majority of the textiles were derived from plant forms and Mackintosh's interpretations were wide-ranging. In some, the subject remains identifiable. Though reduced to a series of arabesques, the central subject of *Roses and Teardrops* (PLATE 46) is clearly the familiar flower. For the majority, however, Mackintosh created new hybrids derived from his extensive botanical knowledge. The flower in *Stylized Plant and Lattice* (PLATE 47) refers to the tulip, but it could as easily be related to the orange 'Chinese lantern' of the Cape gooseberry, or the slender leaves, stem and chequered petals of the fritillaria which Mackintosh had drawn in Walberswick (PLATE 2). In others, Mackintosh pushed his interpretation further to create wholly abstract patterns that are inspired by the movement, colour and markings of plant forms, but which cannot be related to any particular botanical specimen (PLATE 48).

■ ■ ■ Rectilinear shapes were incorporated in a variety of ways. Stripes, grids and diagonals were used as supporting elements disciplining the repeated pattern as in *Stylized Plant and Lattice*. Or, as with the chequered squares in this design, incorporated as a key element to offset the curvilinear organic forms. In others, the geometric and organic were more subtly integrated. A chequered grid provides the basis for a voile design, but the final pattern gives the illusion of the grid having been rippled and distorted into undulating waves, evocative of organic forms. Once repeated over the fabric this design created a pattern which moved with a strong diagonal flow. The repeat is a key element of printed textile design. It can be used to create dense all-over patterns or simple 'sprig' effects. Mackintosh did both. It can also establish, as here, pronounced movement horizontally, vertically or diagonally across the surface of the textile. In this Mackintosh excelled. His mastery of line, whether working with pen, leading for glass panels, cut stencils or other media, was put to new use to contain and control these patterns. It was a line inspired by the restless, diverse forms of organic life.

■ ■ ■ Related to the textiles and the still-life compositions is a small group of floral bouquets (PLATE 49). Seven are documented. In these Mackintosh presents for the first time groups of mixed flowers. Boldly simplified, vividly coloured and set against black backgrounds, these densely patterned compositions were exhibited as works of art in their own right, and also intended for use as textile designs. The current vogue for

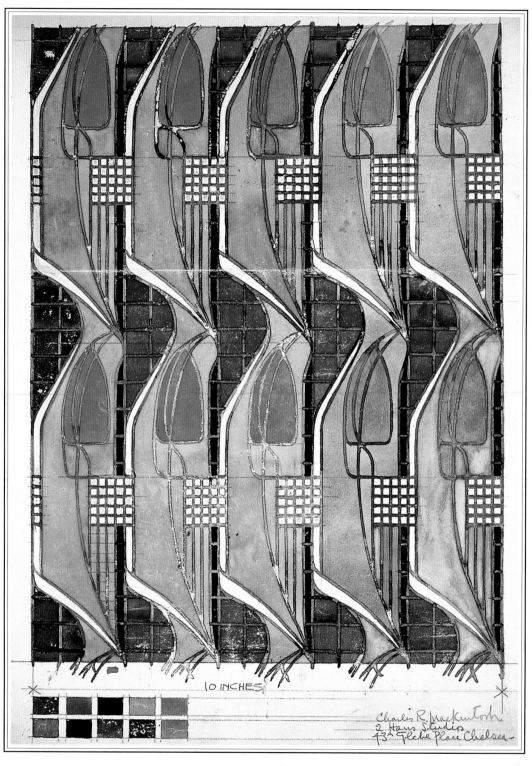

PLATE 47
TEXTILE DESIGN: STYLIZED PLANT AND LATTICE, 1915–23
Pencil and watercolour

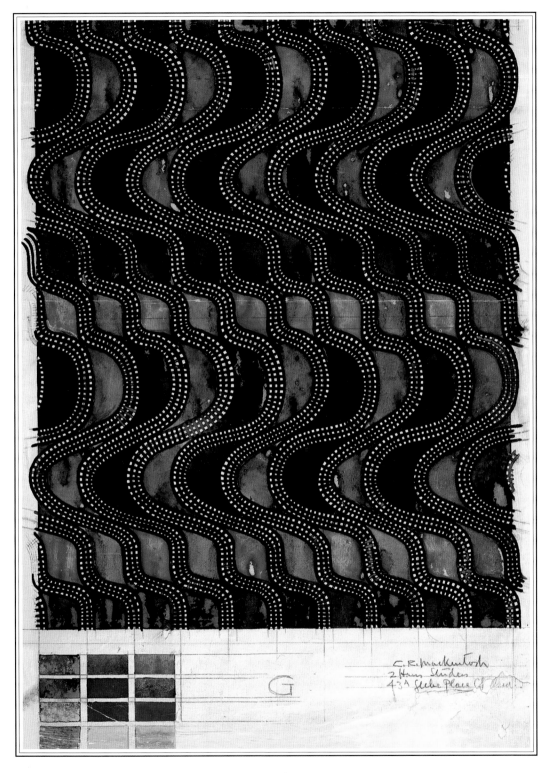

PLATE 48
TEXTILE DESIGN: WAVE PATTERN — GREEN, BLACK AND PINK, 1915–23
Pencil and watercolour

textiles with oriental-inspired designs set against black may have influenced the choice of background. The rich patterns are related to those found in traditional oriental ceramics and textiles, and emulated in products such as Mason's Ironstone pottery (PLATE 38). The closest contemporary parallels to these stylized bouquets are found in the floral designs of George Sheringham and the Frenchman André Mare, or the batiks of the Austrian Else Stübchen-Kirchner.

■■■ In their underlying concepts of stylization and abstraction of form, these exuberant bouquets are related to the austere flower arrangements Mackintosh had created for his Glasgow flat. Contemporary photographs of 120 Mains Street show twisted ball shapes and upright and trailing arrangements created with foliage and selected blooms in a variety of containers (PLATE 66).

■■■ Paradoxically, although the bouquets are artfully manipulated, they celebrate the uninhibited vitality of natural growth. This exuberance is largely conveyed through Mackintosh's constantly moving line, and through colour. While the muted pastel tones of many of his Glasgow designs were applied to some of the textiles, others, in particular the bouquets, flaunt vibrant combinations of bold primaries. The example of the Ballets Russes, which performed regularly in London from 1918 to 1922 to daring designs by Bakst, Benois, Picasso, Matisse and others, invigorated British textile design. Other inspiration would have come from the Continent. In the pre-war years, the pages of *The Studio Year-Books of Decorative Art* had featured vividly coloured and highly stylized floral textiles by progressive German and Austrian designers including Philipp Häusler, C.O. Czeschka, Lotte Frömmel-Fochler and Josef Hoffmann.

■■■ *Palm Grove Shadows* (PLATE 50) appears an oddity in the context of Mackintosh's other London work. The broad handling of the medium and restrained colour scheme set it apart from the still lifes. But its economy is deceptive. The composition has been skilfully worked out. The rectilinear forms of the vertical trunks and the diagonals of the shoreline and horizon are deliberately set between the sweeping curves of the palm branches and their shadows. The whole is daringly cut off at all four edges. Form is modelled through brushwork and tone. This is particularly evident in Mackintosh's handling of the palm branches as he seeks to

PLATE 51
MIXED FLOWERS, MONT LOUIS, FRANCE, 1925
Pencil and watercolour

THIS BOUQUET CONTAINS a rich array of almost twenty species, including *Myosotis* (forget-me-not), *Centaurea* (cornflower), *Epilobium* (willow herb), *Dianthus* (pinks), *Campanula* (bellflower), *Viola* (pansies/violets) and *Geranium* (crane's-bill). Mackintosh has also included a visual joke. At top left is a species of *Rhinanthus* (yellow rattle). Mackintosh has rendered its flowers into birds' heads by adapting the distinctive dark markings of the tips of its petals into bills and eyes.

convey the rhythms of their arched profiles and the intricate patterns created by their overlapping, sunlight-dappled forms. Mackintosh may have found in these patterns the inspiration for certain of his textiles, such as the chequered wave designs.

■ ■ ■ Mackintosh's textiles were the most successful aspect, financially and critically, of his London work. As early as 1917 they were being illustrated in *The Studio*. However, by 1923, his continuing failure to establish a more substantial design practice, or a painting career, contributed to the decision to leave Britain for France, to concentrate on landscape painting. In France, some rare insight into Mackintosh's continuing delight in nature is given in a series of letters written to Margaret Macdonald in the spring of 1927 while she was briefly in London. In these, Mackintosh is eager to describe to her the vivid colour of the genista, the progress of the flowers and seed pods of the cistus shrub, the beauty of their 'Happy Valley'. He speaks lovingly of the fairyland of spring flowers at Mont Louis high in the mountains. Though his principal preoccupation now was with the interpretation of landscape, a small group of studies of the wild Pyrenean flowers survives (PLATE 51). These exuberant mixed bouquets present an extension of the London still-life compositions and textile designs. They represent Mackintosh's last botanical works, and testify to his enduring fascination with, and joy in, the forms of nature.

PLATE 52
PULPIT CARVING, QUEEN'S CROSS CHURCH, GLASGOW, 1899

THE CARVING PROVIDES a powerful metaphor in this Christian context – a bird's wings protect new growth symbolized by stylized sprouting shoots. This finely worked motif was repeated five times round the curved front of the pulpit. Stylized plant forms recur throughout the church, in the chancel furnishings and panelling, and in the carved stone work.

NATURE AND DESIGN

'If we trace the artistic form of things made by man to their origin, we find a direct inspiration from if not a direct imitation of nature.'

C.R. Mackintosh, 'Architecture', 1893

THROUGHOUT MACKINTOSH'S CAREER, PLANT FORMS PROVIDED THE PRINCIPAL SOURCE for the form and detail of his designs. This aspect of his work was in part a response to the nineteenth-century debate on the role of nature, especially plant forms, in the training and practice of designers.

■■■ The Government Schools of Design had been established in 1837 to improve standards of manufacturers' design and to educate public taste. While the syllabus did embrace the study of nature, this was, at first, principally confined to drawing exercises, working gradually from flat copies to actual specimens. The major emphasis in design teaching was on the study of the human figure and historic ornament, in particular the antique.

■■■ The conspicuous failure of this regime encouraged a new school of thought to emerge during the second half of the nineteenth century, which championed the study of nature. Its principal protagonist, A.W.N. Pugin, argued for a return to 'first principles': 'by repeated copying, the spirit of the original work is liable to be lost, so in decoration the constant reproduction of old patterns without reference to the natural type for which they are composed, leads to debased forms and spiritless outline, and in the end to a mere caricature of a beautiful original.'[1] Pugin's arguments were continued in the writings of Henry Cole, Owen Jones, Richard Redgrave, Christopher Dresser and others.

■■■ Mackintosh was undoubtedly aware of this debate as its influence was felt in the Glasgow School of Art. The School's annual report for 1883 to 1884 expresses its continuing allegiance to the South Kensington system while embracing the new philosophy. Acknowledgement is made 'To the Directors of the Botanic Gardens for the generous loan of plants and flowers, and for permission to draw and paint at all hours in the Kibble Palace [the city's principal greenhouse] . . . And the Committee trust such arrangement may still be continued, as, with the works derived from the South Kensington Museum on the one hand, to show what is capable of being done in "applied Design", and, with the Study of Plant-Form, which is the basis of all true Ornamental Art, on the other hand, a condition of things is established which cannot but ultimately end in good results to the art manufacturers of our city.' Mackintosh's

full agreement with the significant role played by nature in design is found in his early lectures: 'If we trace the artistic form of things made by man to their origin, we find a direct inspiration from if not a direct imitation of nature.'[2]

■ ■ ■ All of the theorists advocated close personal study of the forms of nature. A posthumous essay by the Arts and Crafts architect and writer J.D. Sedding, published in 1893, underlines its importance: 'For the professional stylist, the confirmed conventionalist, an hour in his garden, a stroll in the embroidered meadows, a dip into an old herbal, a few carefully drawn cribs from Curtis's Botanical Magazine, or even – for lack of something better – Sutton's last illustrated catalogue, is wholesome exercise, and will do more to revive the original instincts of a true designer than a month of sixpenny days at a stuffy museum. The old masters are dead, but the flowers, as Victor Hugo says, "the flowers last always".'[3] That Mackintosh read and admired Sedding's writings is confirmed by his immediate adoption from this article of one of Sedding's aphorisms: 'There is hope in honest error, none in the icy perfection of the mere stylist.'

■ ■ ■ As a response to these increasingly widely held beliefs, a new literature appeared dealing with nature as a design resource. Many influential figures, often themselves practising designers and artists, including Walter Crane, G.W. Rhead, Lewis Day and Christopher Dresser – the latter also a trained botanist – went into print. By the turn of the century, however, a lack was apparent to the architect W.G. Paulson Townsend: 'An inexpensive collection of plant studies in line, from a structural point of view, of a purely practical nature is greatly needed.' In his view the only worthwhile predecessors were Frederick Edward Hulme's *A Series of Sketches from Nature of Plant Form* of 1868 and George Charles Haité's *Plant Studies for Artists, Designers and Art Students* published in 1886 – both long out of print. Townsend aimed his criticism in particular at manuals in which 'Students are much hampered by hints or suggestive designs based on, and placed by the side of, the plant studies' Townsend's response, *Plant and Floral Studies for Designers, Art Students and Craftsmen*, was published in 1902. That Mackintosh's flower drawings may have been his own response to- this lack is supported by the evidence of his friend Desmond Chapman-Huston. In a memorial article for the periodical *Artwork* written in 1930,

two years after Mackintosh's death, Huston recalled: 'In 1899 with the object of helping young designers he had started a series of flower studies of great beauty.' While Huston was often inaccurate in matters of detail, here possibly the dating, the article was published shortly after Mackintosh's widow had spent several months in Huston's household and there must be a general truth behind this statement. It suggests that Mackintosh had considered publishing his flower drawings some years before 1914 and the Walberswick watercolours, not as a picture book but as a design reference tool.

■ ■ ■ Though nature might rule supreme as a source, her forms were not to be slavishly imitated. As Owen Jones declared in his influential work *The Grammar of Ornament*, 'the more closely nature is copied the farther we are removed from producing a work of art.' Mackintosh put it more bluntly, 'servile imitation of nature is the work of small minded men'. New forms were to be created, and their use governed by appropriateness. Jones continued: 'Flowers or other natural objects should not be used as ornaments, but conventional representations founded upon them sufficiently suggestive to convey the intended image to the mind, without destroying the unity of the object they are employed to decorate.'[4]

■ ■ ■ Mackintosh again was in accord. He believed the inventive use of the forms of nature – not adherence to tradition or authority – was the way forward for architects and craftsmen. In his 1902 lecture, 'Seemliness', he declared, '[the artist] must possess technical invention in order to create for himself suitable processes of expression – and above all he requires the aid of invention in order to transform the elements with which nature supplies him and compose new images from them. All good work is thoughtful and suggestive – carefully reasoned – and characterized no less by wide knowledge – than by closeness of observation and instinctive appropriateness.' Flowers were used as the symbol in the culminating challenge to his audience of artists and writers: 'Art is the flower – life is the green leaf. Let every artist strive to make his flower a beautiful living thing – something that will convince the world that there may be – there are – things more precious – more beautiful – more lasting than life. But to do this you must offer real living – beautifully coloured flowers – flowers that grow not from but above the green leaf – flowers that are not dead – are not dying – not

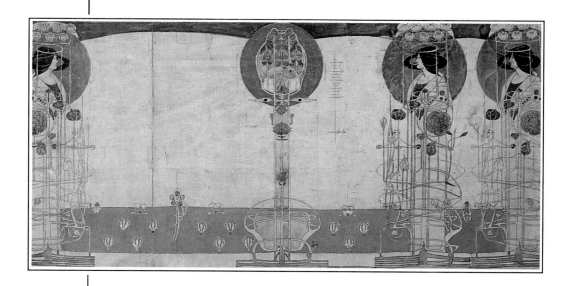

PLATE 53
DESIGN FOR MURAL DECORATION. MISS CRANSTON'S TEA ROOMS, BUCHANAN STREET, GLASGOW, 1896
Pencil and watercolour

MACKINTOSH'S six-foot (two-metre) high women grew out of stylized thickets bearing buds, leaves and rose blooms. They decorated the walls of the Ladies' Tea Room on the first floor.

artificial – real flowers springing from your own soul – not even cut flowers – you must offer the flowers of the art that is in you – the symbols of all that is noble – and beautiful – and inspiring – flowers that will often change a colourless cheerless life – into an animated thoughtful thing.'[5]

■ ■ ■ The general principles advocated by Owen Jones and others were followed in practice by Mackintosh. Surprisingly, he alone of The Four is known to have drawn plants from life, though the Macdonald sisters and McNair all used plant forms in their design work. His adaptations of plant forms for decorative motifs were innovative and based on close study of the original. The rose, a favourite motif, well illustrates this. Studies of the flower appear in the sketchbooks of the late 1880s (PLATE 4) and it is first used as a decorative device in the stencil designs for Miss Cranston's Tea Rooms in Buchanan Street, Glasgow – his first major interior commission – in 1896 (PLATE 53). By 1898, with the cabinet designs for the German publisher, Hugo Brückmann, it has been stylized into a versatile linear motif which was to be applied to many media including gesso, glass, textiles, metal, ivory and wood, and is seen at its most elaborate in the doors for the Room de Luxe, Glasgow (PLATE 54).

INTENSELY WORKED LINEAR PATTERNS such as this characterized the Mackintoshes' decorative panels of the early 1900s. The doors provided a fitting entrance to the jewel-like silver and purple interior of the Room de Luxe.

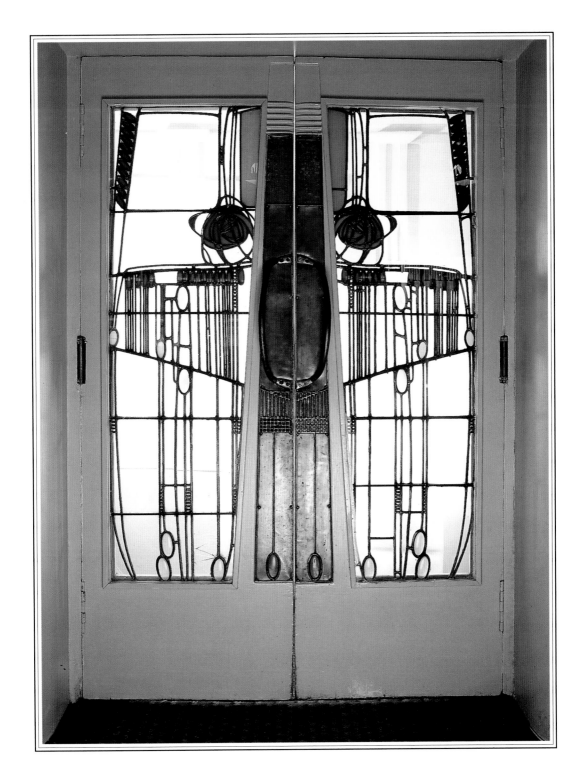

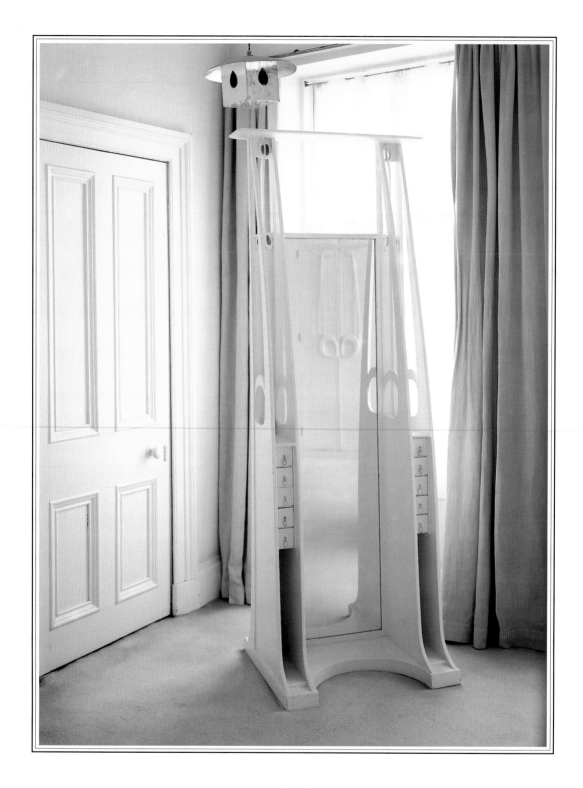

PLATE 55
CHEVAL MIRROR, 120 MAINS STREET, GLASGOW, 1900
Painted oak with glass insets and silvered brass handles

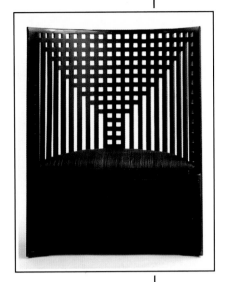

Plate 56
Order Chair, Willow Tea Rooms, Glasgow, 1904
Ebonized oak

IN THIS DESIGN the tree has been radically simplified to an arrangement of squares while the ebonized finish disguises the natural surface and grain of the timber.

■■■ Mackintosh's application of plant motifs was selective and decorative. Ornament was not allowed to overwhelm a design: rather, it was used to enhance its formal qualities – providing, for instance, a touch of colour in a plain surface or a curvilinear form to offset a rectilinear structure. Mackintosh subscribed to the Puginian credo that construction should be decorated, not decoration constructed.

■■■ But Mackintosh did not just absorb the potential of plant forms as a source for applied ornament; the principles of their formal evolution informed his designs. Again and again, the vertical thrust of organic growth, for example, is applied to columns, windows, posters, banners and furniture (PLATE 55). And, as Howarth notes, the abstract principles of their structure were also assimilated. Early on, Mackintosh 'discovered that no two leaves on the same tree were identical and that each petal on every flower had distinctive characteristics and could not be matched in texture, shape or colour. Such lessons he was not slow to apply in practice, and many of his later designs possess an elusive charm and vitality due entirely to subtle variations in detail achieved without impairing the balance or unity of the whole.'[6] Mackintosh was sensitive to what he referred to in 'Seemliness' as 'the hushed reserve that is always felt in nature, the precious reserve that only true art possesses'.

■■■ In key areas, however, Mackintosh is at a distance from the principles of designing from nature championed by his contemporaries. While in his writings Mackintosh praised the concept that nature's forms combined beauty with utility, in practice form often outranked function. Equally, Mackintosh was not concerned with

ORGANIC FORMS inspired the swept and tapered forms of this sleek design. The mirror was designed for the Mackintoshes' first marital home in 1900. It is shown here *in situ* in The Mackintosh House of the Hunterian Art Gallery at the University of Glasgow.

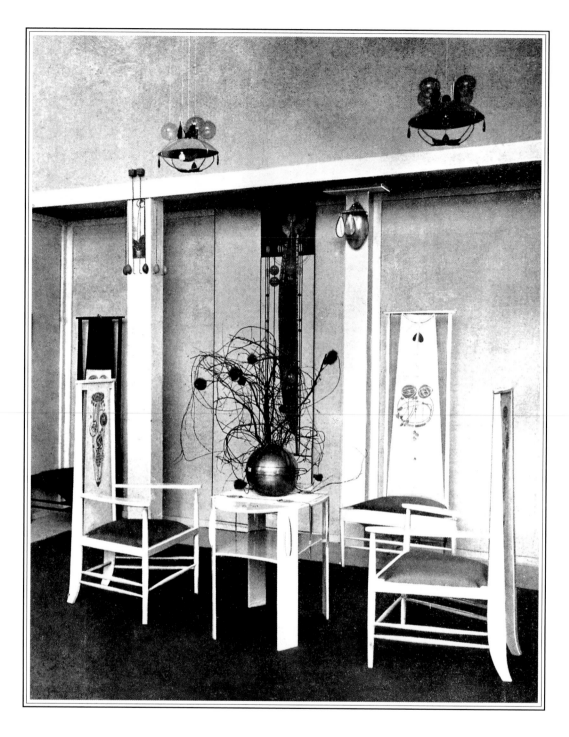

Plate 57

C.R. Mackintosh and Margaret Macdonald Mackintosh
Detail of 'The Rose Boudoir', Turin, 1902

This view shows the central group of furniture and illustrates the diversity of object, material and technique orchestrated by the Mackintoshes in the creation of their unified setting.

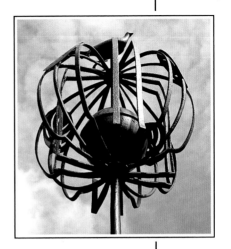

PLATE 58
FINIAL, GLASGOW SCHOOL OF ART, *c.* 1899
Painted iron

Two FINIALS surmount the roof of the School. Each presents different interpretations of two of the city's emblems: the bird and the tree.

exploiting the inherent beauties of nature's materials, such as the grain of a choice timber. Nor was he concerned to present the physical evidence of workmanship – the expression of the relationship between maker and material, artist and nature – as a valued part of an object's beauty. In Mackintosh's hands, nature's forms were idealized and abstracted from association with the material world (PLATE 56). The otherworldliness of Mackintosh's vocabulary was recognized by Mackintosh's contemporary and friend, the German architect and critic Hermann Muthesius: 'Mackintosh's rooms are refined to such a degree which the lives of even the artistically educated are still a long way from matching. The delicacy and austerity of their artistic atmosphere would tolerate no admixture of the ordinariness which fills our lives.'[7]

■ ■ ■ Muthesius's comments are well illustrated by the Mackintoshes' exhibit at the 1902 International Exhibition of Modern Decorative Art at Turin. Their room setting *'The Rose Boudoir'* was one of the most critically acclaimed presentations at this prestigious exhibition, and the most widely acclaimed interior of their lifetimes (PLATE 57). The room showcased collaboration between Mackintosh and Margaret Macdonald, presented innovative concepts in exhibition design and displayed Mackintosh's use of plant forms at its most sophisticated. Out of the cavernous exhibition hall, Mackintosh created a rarefied interior. Into a simple framework, defined by picture rails, screens and square columns, Mackintosh placed some half dozen pieces of furniture, two gessos, two embroidered hangings, and a small group of framed watercolours and graphics.

■ ■ ■ The rose, both as colour term and flower, informed the scheme of pink, silver and white. Rose motifs appeared in the furniture, hangings and decorative panels. Even the lightshade reflectors derived from the rose – hanging as pink ovoids, like petals. Commentators responded to the mystical and otherworldly character of the room. It was a 'dream', an 'intellectual ideal', the 'breath of refinement'. Muthesius concurred. For him, a distinctive characteristic of Mackintosh's work was its

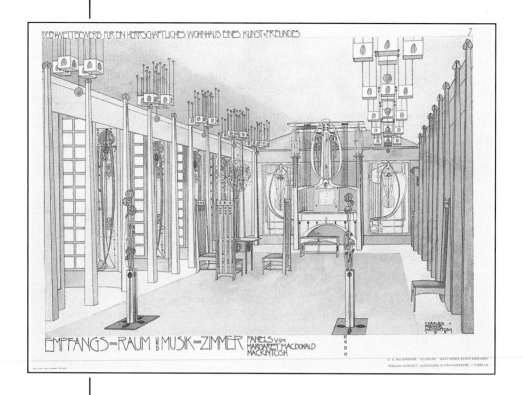

IDEENWETTBEWERB FÜR EIN HERRSCHAFTLICHES WOHNHAUS EINES KUNST=FREUNDES

EMPFANGS=RAUM und MUSIK=ZIMMER PANELS VON MARGARET MACDONALD MACKINTOSH

PLATE 59
MUSIC ROOM, A HOUSE FOR AN ART LOVER, 1901
Lithograph

THOUGH SPARSELY FURNISHED, the interior was embellished with decorative banners emblazoned with
rose motifs and an elaborately carved casing for the piano.

'emotional and poetical quality. It seeks a highly charged artistic atmosphere or more
specifically an atmosphere of a mystical, symbolic kind.'

■ ■ ■ Though by the mid 1890s, Mackintosh had ceased to paint symbolist
watercolours, symbolic motifs continued to inform much of his design work and were
used in a number of different ways. In the stencilled decorative schemes for the
Buchanan Street Tea Rooms of 1896, colour, for example, is used symbolically. The
transition between the three floors is marked by a changing colour scheme for the
walls. Each floor was demarcated by a band of colour: green for lower earth; greenish
yellow for middle earth; and blue for the sky – concepts which derived from
Scandinavian mythology. Elsewhere more specific symbols are used, such as devices
from family crests, or generalized motifs such as a tree to refer to the Trees of
Knowledge and Life, or to Glasgow and its coat of arms (PLATE 58). Mackintosh regularly
leavens his designs with wit, with visual conceits. The shape of a plump apple is chosen
as an appropriate device to model into the seats of the Argyle Street Tea Room chairs,

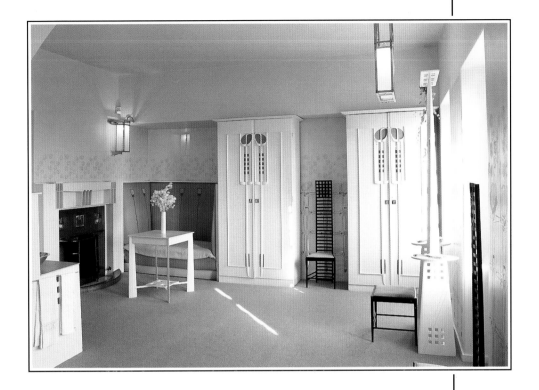

PLATE 60
PRINCIPAL BEDROOM, THE HILL HOUSE, HELENSBURGH

A STENCILLED ROSE BRIAR in soft shades of mauve and grey was applied to the walls. Each repeat expressed the blossoming of a rose from tight bud in the lower trellis to fully opened bloom in the top section, with, above that, petals scattered in the wind. These organic motifs were skilfully offset by the rectilinear detailing of the furniture, in particular Mackintosh's famous ebonized ladderback chair.

providing a welcoming niche for the posteriors of Miss Cranston's clients. Elsewhere in the Tea Rooms, decorative metal rings are added to the supporting wires of the billiard room light-fittings to symbolize smoke rings, an apt motif for the muggy atmosphere of this male preserve. However, from the early 1900s, with designs such as *'The Rose Boudoir'*, symbolic content became more complex.

■ ■ ■ On one level, the Boudoir can be read as a celebration of the rose, its formal inspiration. But Mackintosh's lifelong preoccupation with this flower was based on more than its decorative potential. No other flower type was used with anything like the same regularity. As Timothy Neat has argued, the rose had specific meaning for Mackintosh as a symbol of art, beauty and love.[8] In 'Seemliness', he symbolized art as the flower nourished by the green shoots of life. For him that flower was the rose.

■ ■ ■ The relevance of this to *'The Rose Boudoir'* becomes clearer if the room is considered, not in isolation, but as an intermediate setting between two other interiors. In 1900 Mackintosh entered a German competition to design a 'House for an Art

PLATE 61

DESIGN FOR A PLASTER PANEL FRIEZE, WILLOW TEA ROOMS, GLASGOW, 1903
Pencil and watercolour

MACKINTOSH appears to have presented two alternatives: that selected with a plain background, and another incorporating a dense rose pattern. The overall composition is related
to the early watercolour *'The Tree of Personal Effort'* (Plate 17).

Lover'. A centrepiece of his entry was an exquisite white and silver music room, austerely furnished and decorated with rose motifs (PLATE 59). This proposal undoubtedly prompted the commission from Fritz Wärndorfer, a sophisticated art collector and patron of the Wiener Werkstätte, for a comparable music room for his Viennese town house. The room was under construction at the time of the Turin display. All of the major items at Turin – the chairs, gessos and writing cabinet – were bought by Wärndorfer even before the exhibition opened. It is more than likely that the Turin furnishings were conceived with Wärndorfer in mind, and sent as prototypes for his music room, to be approved by him at Turin. If so, the inner symbolism of *'The Rose Boudoir'* can be explained: it is an idealized setting for a connoisseur of the arts. The creation of symbolic environments derived from trees and other plant forms was a recurring theme in the interiors of the early 1900s: maypole trees define a play area in the House for an Art Lover nursery; a rose briar embraces the principal bedroom of The Hill House (PLATE 60); and a grove of trees of knowledge provides the framework for the library of the Glasgow School of Art.

■ ■ ■　The tree provided the inspiration for another set of interiors created for the doyenne of Glasgow Tea Rooms, Catherine Cranston. Miss Cranston shared Mackintosh's great love of flowers. Three times a week fresh blooms were brought from her gardens to the city-centre Cranston establishments. The interior schemes Mackintosh designed for the tea rooms in Buchanan Street and Ingram Street were enriched with floral motifs. For her most ambitious tea room, for which Mackintosh acted as both

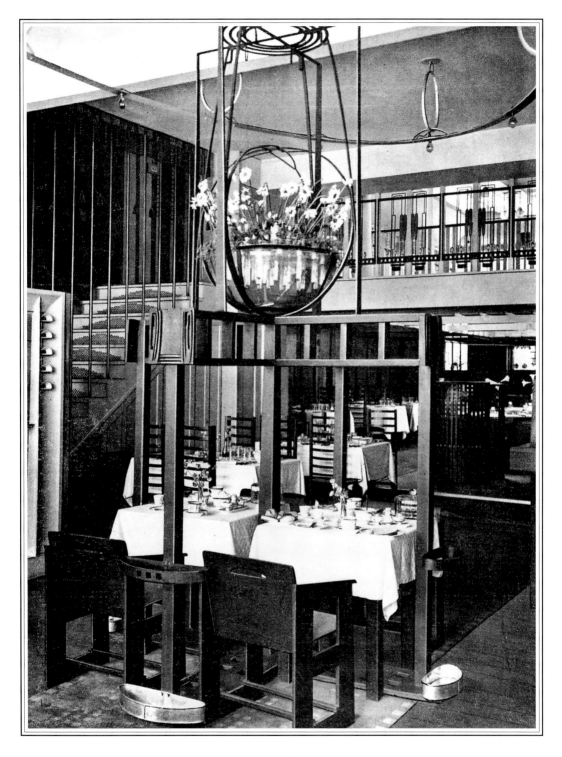

PLATE 62
FRONT TEA ROOM, WILLOW TEA ROOMS, GLASGOW, 1903

THE ORDER CHAIR (Plate 56) can be seen in the middle right, in its location between the front tea room and the rear dining room.

PLATE 63

QUEEN'S CROSS CHURCH, GLASGOW — WEST ELEVATION

THIS EARLY DETAIL typifies the sinuous linear movement of Mackintosh's early organic designs.

architect and interior designer, the name and decorative theme derived from its address in Sauchiehall Street. 'Sauchiehall' is old Scots for 'Way of the Willows'. For the Willow Tea Rooms, Mackintosh designed panels, fabrics and furniture inspired by the leaves and form of the willow tree. One of the most dramatic features was a nine-foot (three-metre) high flower container. Its elaborate structure straddled two tables in the ground-floor dining room and supported a large transparent glass bowl inside which were suspended test-tubes for holding flowers. Either side of the front tea room was a frieze of plaster panels creating an enclosing willow wood (PLATE 61). The panels present Mackintosh's most abstract stylization of a tree. The only identifiable botanical element is the blade-shaped leaves of the willow. A more intense atmosphere was created in the richly decorated, silver and purple Room de Luxe. There the focal point was Margaret Macdonald's five-foot (1.5-metre) high gesso panel illustrating D.G. Rossetti's sonnet 'O Ye that Walk in Willowwood', with its melancholy theme of the perpetual wandering of the souls of broken-hearted maidens.

■ ■ ■ Subsequent commentators have viewed the decorative elements of such interiors as the corrupting feminine influence of Margaret Macdonald. While she was undoubtedly influential in the intellectual programme of the interiors, it is clear that from the outset, the architectonic and the organic had coexisted in Mackintosh's work; at times on the same page of a sketchbook. Within a few years of the Willow, geometric detailing had largely replaced plant forms in Mackintosh's decorative vocabulary (PLATES 63 and 64). In London, however, floral motifs reappeared in the textiles, and the tree once more provided the inspiration for a dramatic interior scheme (PLATE 65).

PLATE 66
DRAWING ROOM, 120 MAINS STREET, GLASGOW

ON THE MANTELPIECE, from the left, are a milk bottle, a Chinese ginger jar, an Austrian Zara seal liqueur bottle, and a metal hemisphere probably to Mackintosh's design.

■ ■ ■　On a few occasions Mackintosh had the opportunity to work directly with nature: on an intimate scale, in his own home; and on a wider scale with garden design. The contemporary photographs that survive of Mackintosh's studio-bedroom, and of the interior of 120 Mains Street, Blythswood Square, Glasgow, the flat he lived in from 1900 to 1906 (PLATE 66), show unusual flower arrangements in a variety of unconventional containers chosen for their shape and colour – Chinese ginger jars, liqueur bottles, even milk bottles – or vertical vases or metal hemispheres to his own design. The twisted ball shapes and upright and trailing arrangements created with foliage and selected blooms played a carefully judged part in the overall decorative scheme. Mackintosh's perfectionism in this is recorded by Mary Newbery Sturrock. While Newbery and Mackintosh were in Turin for the 1902 exhibition, 'Mackintosh went and arranged their bit inside the pavilion, and when it was finished Daddy said, "Now, order some flowers," then Mackintosh leapt in the air – nearly tore him to pieces. "No flowers in my room but my flowers!" So Daddy took him into the country and they picked a twig here and a trailer there and he made it up into what he wanted.'[9] Interestingly, the flower heads in *The Rose Boudoir* were of coloured tissue, a choice dictated by the practical need to simplify maintenance of the display, but one which would also guarantee the look of the arrangement throughout the exhibition.

■ ■ ■　Certain aspects of Mackintosh's flower arrangements are related to the Japanese tradition, which had been richly illustrated in *The Studio* in a series of three articles in 1896: the use of simple but characterful containers; the preference for simplicity in the selection of flowers and greenery; the sensitivity to line in the

A RANGE OF STYLIZED TREES was set against the black walls: their trunks black and white chequers; their foliage a richly coloured frieze of triangular motifs in gold, grey, vermilion, blue, green and white, as shown in this design.

arrangement. But Mackintosh ignored many of its strictures, including the need to maintain integrity between content and season and habit, or to express qualities of growth and vitality appropriate to the subject. Indeed at times plant forms were deliberately manipulated to create unnatural 'motifs' within an interior. The Mackintoshes' distinctive twisted ball arrangements, for example, were achieved by stripping the leaves from trailers of *Clematis montana* and winding and fixing the resultant bare stems round a central branch.

■ ■ ■ As Mackintosh received few commissions for houses – the most significant of which were Windyhill, Kilmacolm (1899) and The Hill House, Helensburgh (1902) – he had, unlike his English architect contemporaries, few opportunities to practise garden design. The steeply sloped site at Windyhill allowed little scope, while at The Hill House, Mackintosh's patron, Walter Blackie, played a large part in the layout of the grounds. Nevertheless the executed designs for The Hill House reveal a concern with relating the architecture to the garden both through projecting window bays, a verandah and stairways, and through garden furnishings: trellising, arbours, dovecots, archways and seating. Even the walls and gates enclosing the garden received careful attention (PLATE 67). Great care was taken to site the house to best advantage, as Fernando Agnoletti noted. Agnoletti, at that time teaching at Glasgow University, undoubtedly had direct contact with Mackintosh when preparing his descriptive article: 'The feeling that a glance at the house creates, that it forms the main link in a chain of rising forms and colour, is much less the result of the natural beauty which the situation actually presents, as the artistic utilization of every available material. So, for instance, the straight line from the white steps in the green and hilly terrace, continuing its direction to the higher steps up to the pointed roof of the garden house and from which it rises to a point of the gable, is far from being a chance formation. By it our eyes are led unconsciously towards the higher green fields just below the villa and from there up to its roof, to the spot where small narrow roofs grow out of the construction of the walls, and continue the rising movement of the building.'[10]

■ ■ ■ Two other projects provided scope, if limited, for garden design. The first was for the remodelling of 78 Derngate, Northampton in 1916. There Mackintosh built a shallow extension to the rear garden façade to provide balconies at first- and second-

PLATE 67
THE HILL HOUSE, HELENSBURGH — VIEW FROM THE
SOUTH-WEST

THE HILL HOUSE sits high above the town of Helensburgh, enjoying panoramic views south over the River Clyde.

floor level, bedecked the ground-floor window with window boxes, and introduced trellising and cube-shaped shrub boxes in black and white into the narrow paved garden. The second was for a small paved roof garden for Harold Squire's London studio in 1920. That scheme incorporated rough squared stones, cherry trees and a fountain. Unfortunately, nothing is known of the only garden Mackintosh himself owned, from 1906 to 1920, at 78 Southpark Avenue, Glasgow.

■ ■ ■ At the turn of the century, nature was the principal decorative source for designers throughout Europe and in America. What distinguishes Mackintosh's use of plant forms is the degree to which he would simplify and abstract motifs; his symbolism, at times mystical or personal; and his disciplined counterbalancing of the organic with the architectonic. In his interiors, plant forms contributed a telling and often central part of an orchestrated whole, as both visual motif and intangible spirit, infusing form and theme. The closest contemporary parallels in the design interpretation of plant forms were with the work of the Vienna Secessionists, with whom Mackintosh had direct personal contact around 1900. In America, Frank Lloyd Wright, independently, matched his abstract stylizations. Mackintosh established neither a design office nor a school to propagate his style. His only major collaborator was Margaret Macdonald. Nonetheless, in his native city at least, in his lifetime the developing design style, the 'Glasgow Style', owed much to his example. More recently, in the 1980s and 1990s, there has been an extraordinary revival of interest in Mackintosh's decorative motifs, for products as diverse as tea cosies and bed linen. Much of this comprises the superficial application of roses and squares in shades of purple, green and black. This 'Mockintosh' style denies the fundamental principles of Mackintosh's considered thoughtfulness in design.

■ ■ ■ Plant forms touched many aspects of Mackintosh's output, both professional and private. They enriched in particular the decorative designs of 1897 to 1905, the late textile designs and his graphic work throughout his career. Whether stylized or objective, their presentation was innovative and considered. When seeking to describe the position of art in the order of things, Mackintosh looked once more to nature for the telling image: Art was the flower which sprang from the green shoots of life.

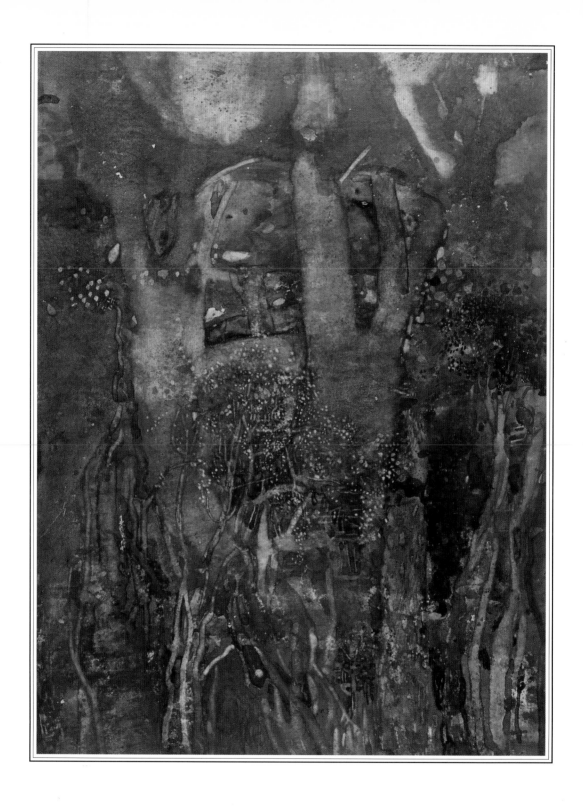

PLATE 68
AT THE EDGE OF THE WOOD
Watercolour

AFTERWORD

I N HIS AUTHORITATIVE MONOGRAPH, *THE ART OF BOTANICAL ILLUSTRATION*, WILFRID Blunt concluded: 'The greatest flower painters have been those who have found beauty in truth; who have understood plants scientifically but who have seen and described them with the hand and eye of the artist.' No finer summary exists to typify Mackintosh's achievement as a botanical artist. Yet recognition of Mackintosh's achievement as a floral painter and textile designer was limited both in his lifetime and for many years after his death. It was not until the 1933 Mackintosh Memorial Exhibition in Glasgow that his paintings and textile designs were first seen publicly in any quantity. Over a dozen flower drawings, eight still-life compositions and a representative group of textile designs and bouquets were exhibited. Nearly all of them were sold. But Mackintosh as a painter did not surface again for over forty years, until the revelatory exhibitions of the late 1970s at the Hunterian Museum and the City Art Gallery in Glasgow, and the related publications by Roger Billcliffe. Today Mackintosh is regarded as an artist-architect of international stature.

THIS COMPOSITION appears to have emerged out of the random effects created by floating coloured washes on the sheet, rather than being first established through drawing. The surface has then been sponged and worked and further touches of pigment added.

ENDNOTES

CHAPTER I

1. F.H. Newbery, 'On Training of Architectural Students', *Proceedings of the Philosophical Society of Glasgow* (19) 1889, p.190.
2. Sir James Watson, Annual Prize-Giving Address, *Glasgow School of Art Annual Report* 1885–6, p.11.
3. C.R. Mackintosh, 'Scotch Baronial Architecture' (1891) in ed. Pamela Robertson, *Charles Rennie Mackintosh: The Architectural Papers* (Wendlebury 1990) pp.49–50.
4. Four sketchbooks coll. Hunterian Art Gallery, University of Glasgow; two sketchbooks coll. National Library of Ireland, Dublin. The majority of the loose drawings are owned by the Hunterian Art Gallery.
5. A possible exception is raised in Desmond Chapman-Huston's memoir of Mackintosh, published in *Artwork* (6), 1930. Chapman-Huston suggested that some of the early flower drawings were intended for publication as a teaching aide for young designers. There is no evidence that this project materialized.
6. 'Studio-Talk: Glasgow', *The Studio* (19) 1900, p.51.
7. Quoted in press-cutting of 22 May 1895 in *Newspaper Cutting Book* (1) n.p. Coll. Glasgow School of Art.
8. Thomas Howarth, *Charles Rennie Mackintosh and the Modern Movement* (2nd edn: London 1977) p.6, n.1 names Hodebert, but no artist of that name has been traced. However, a Léon-Auguste-César Hodebert (1851–1914), artist, printmaker and teacher, was based in Rouen from 1882 to 1888. It would seem likely he was McNair's tutor.

■ ■ ■

CHAPTER II

1. William Hardie, *Scottish Painting: 1837 to the Present* (3rd edn: London 1990) pp.115–16.
2. Ed. Pamela Robertson, *Charles Rennie Mackintosh: The Architectural Papers* (Wendlebury 1990) pp.199 and 222.

■ ■ ■

CHAPTER III

1. M.M. Mackintosh to Anna Geddes, 14 January 1915. Coll. National Library of Scotland, MS/10582/16.
2. Frank Dillon, 'Studies by Japanese Artists', *The Studio* (3) 1894, p.36.
3. E.A. Hornel, *Japan* (Castle Douglas n.d.).

CHAPTER IV

1. Mackintosh's struggle with the Home Office is charted in a series of letters to William Davidson; 18, 19 June; 21, 29 July; 5 August 1915. Coll. Hunterian Art Gallery, University of Glasgow.
2. T. Martin Wood, 'Modern Flower Painting', *The Studio* (60) 1913, pp.89–98.
3. 'London Reviews: Goupil Gallery Salon' *The Studio* (86) 1923, pp.330 and 337.
4. Davidson correspondence, 1 April 1919.
5. The principal holding of textile designs is owned by the Hunterian Art Gallery, University of Glasgow; a smaller group is owned by the Victoria and Albert Museum, London. Original samples comprise 1) Victoria and Albert Museum – T439-1934: Roller-printed cotton produced by W. Foxton (PLATE 4/11); T43-1953: Printed silk produced by W. Foxton c.1919; T.85-1979: Printed cotton probably by CRM, produced by W. Foxton, 1918; 2) Whitworth Art Gallery, University of Manchester – T.1.1991 Roller-printed cotton probably by CRM, produced by W. Foxton.
6. William Foxton, 'Household Gods', *The Architect* (96) 1916, p.299.

■ ■ ■

CHAPTER V

1. A.W.N. Pugin, *Floriated Ornament* (London 1849) p.3.
2. C.R. Mackintosh, 'Architecture' (1893) in ed. Pamela Robertson, *Charles Rennie Mackintosh: The Architectural Papers* (Wendlebury 1990) pp.204–5.
3. J.D. Sedding, 'Design' in *Arts and Crafts Essays* (London 1893) pp.412–13.
4. Owen Jones, *The Grammar of Ornament* (London 1856) p.154 and Proposition 13; C.R. Mackintosh 'Architecture' (1893) in ed. Robertson, p.209.
5. C.R. Mackintosh, 'Seemliness' (1902) in ed. Robertson, p.224.
6. Thomas Howarth, *Charles Rennie Mackintosh and the Modern Movement* (2nd edn: London 1977) p.7.
7. Hermann Muthesius, *The English House* (Berlin 1904–5); English version ed. Dennis Sharp (Oxford 1979) p.52.
8. Timothy Neat, *Part Seen, Part Imagined* (Edinburgh 1994) p.32 and *passim*.
9. Mary Newbery Sturrock, 'Remembering Charles Rennie Mackintosh', *The Connoisseur* (183) 1973, p.282.
10. Fernando Agnoletti, 'The Hill House', *Deutsche Kunst und Dekoration* (15) 1905, pp.337–68.

As well as landmarks in Mackintosh's life, this chronology gives the commencement dates for his principal design projects; these may have subsequently taken several years to complete or have been worked on in stages. The chronology also lists the principal known lifetime exhibitions of watercolours.

1868 Born in Glasgow, 7 June

1875 Attends Reid's Public School, Glasgow

1877 Attends Allan Glen's School, Glasgow

1883 Begins evening classes at Glasgow School of Art

1884 Apprenticed to John Hutchison, Glasgow

1885 Francis Newbery appointed Headmaster of Glasgow School of Art

1886 Glasgow School of Art Club established

1888 J.H. McNair joins John Honeyman as an apprentice architect

1889 John Honeyman takes John Keppie into partnership
Mackintosh joins Honeyman & Keppie as an architectural draughtsman

1890 Margaret and Frances Macdonald enrol at Glasgow School of Art
Wins Alexander Thomson Travelling Studentship

1891 Tour of Italy

1893 First issue of *The Studio*; first number of 'The Magazine'
Glasgow Herald building extension

1894 Glasgow Institute: exhibits *'The Harvest Moon'*

1895 Martyrs' Public School, Glasgow
Poster designs

1896 Glasgow School of Art – first phase
Miss Cranston's Tea Rooms, Buchanan Street, Glasgow – decorations
5th Arts and Crafts exhibition, London
Poster designs

1897 Queen's Cross Church, Glasgow

1898 Royal Scottish Society of Painters in Watercolour: exhibits *'Princess Ess'*; *'Princess Uty'*
Miss Cranston's Tea Rooms, Argyle Street, Glasgow – furniture

1899 The International Society of Sculptors, Painters and Gravers, London (ISSPG): exhibits *'The Black Thorn'*; *'The Moss Rose'*
Royal Glasgow Institute: exhibits *'Princess Ess'*
International Biennale, Venice: exhibits *'Princess Uty'*

1900 120 Mains Street, Glasgow – interiors
Miss Cranston's Tea Rooms, Ingram Street, Glasgow – interiors
Windyhill, Kilmacolm
Marries Margaret Macdonald
8th Vienna Secession exhibition
Daily Record building

1901 Becomes a partner in Honeyman, Keppie & Mackintosh
A House for an Art Lover competition entry
Liverpool Anglican Cathedral competition entry

1902 The Hill House, Helensburgh
Music room for Fritz Wärndorfer, Vienna
'The Rose Boudoir', Turin

1903 Willow Tea Rooms, Glasgow
Scotland Street School, Glasgow

1904 Hous'hill, Glasgow – interiors

1906 78 Southpark Avenue, Glasgow – remodelling and interiors

1907 Glasgow School of Art – second phase

1913 Resigns from Honeyman, Keppie & Mackintosh

1914 Arts Décoratifs de Grande Bretagne et d'Irlande, Paris: exhibits *'Le Jardin'*
Moves to Walberswick

1915 Moves to London

Select Chronology

1916 78 Derngate, Northampton – remodelling and interiors
11th Arts and Crafts exhibition, London
ISSPG: exhibits *Anemones*
Takes up commercial textile design
Willow Tea Rooms, Glasgow – interior

1917 ISSPG: exhibits *Petunias*

1918 ISSPG: exhibits *Begonias*

1920 Studio and theatre designs, London
British Arts and Crafts Exhibition, Detroit and tour: exhibits *Anemones* and *Petunias*

1922 2nd International Water Color Exhibition, Chicago: exhibits *The Road from the Ferry*

1923 3rd International Water Color Exhibition, Chicago: exhibits *Roses*
Moves to the South of France
13th Goupil Gallery Salon, London: exhibits *Pinks*

1924 4th International Water Color Exhibition, Chicago: exhibits *Yellow Tulips*

1925 5th International Water Color Exhibition, Chicago: exhibits *The Grey Iris*

1926 6th International Water Color Exhibition, Chicago: exhibits *Collioure (Pyrénées Orientales)*

1927 British Artists' Exhibition, Paris: exhibits *Le Fort Mauresque*

1928 Dies in London, 10 December

1933 Margaret Macdonald Mackintosh dies in London, 7 January
Mackintosh Memorial Exhibition, Glasgow

Select Bibliography

Roger Billcliffe *Charles Rennie Mackintosh: Architectural Sketches and Flower Drawings* London, 1977

Roger Billcliffe *Charles Rennie Mackintosh: The Complete Furniture, Furniture Drawings & Interior Designs* 3rd edn London, 1986

Roger Billcliffe *Mackintosh Watercolours* 3rd edn London, 1993

Roger Billcliffe *Mackintosh Textile Designs* San Francisco, 1993

David Brett *Charles Rennie Mackintosh: The Poetics of Workmanship* London, 1992.

ed. Jude Burkhauser *Glasgow Girls* Edinburgh, 1990

Alan Crawford *Charles Rennie Mackintosh* London, 1995

Thomas Howarth *Charles Rennie Mackintosh and the Modern Movement* 3rd edn London, 1990

Alistair Moffat *Remembering Charles Rennie Mackintosh* Lanark, 1989

ed. Pamela Robertson *Charles Rennie Mackintosh: The Architectural Papers* Wendlebury, 1990

The bibliography in Crawford provides a useful further reading list for Mackintosh as an architect and designer.

Public Collections

Glasgow houses the major collections of Mackintosh's work. The largest and most representative is at the Hunterian Art Gallery of the University of Glasgow, founded on the Mackintosh Estate and the contents of the Mackintoshes' Glasgow home, 78 Southpark Avenue. Important collections of furniture and watercolours are also housed at Glasgow School of Art and Glasgow Museums. Some works remain in the possession of the descendants of Mackintosh, his friends and patrons. But increasingly his work is being dispersed around the world, from Australia to America to Japan – a telling and fitting measure of Mackintosh's now well-established international reputation.

In addition to the Glasgow collections, the following public collections own examples of Mackintosh's floral graphic work:

Botanical studies: British Museum, London; Graves Museum, Sheffield; Victoria and Albert Museum, London; National Library of Ireland, Dublin.

Still-life compositions: Detroit Institute of Art; Metropolitan Museum of Art, New York.

Textile designs: British Museum, London; Victoria and Albert Museum, London; National Gallery of Australia, Canberra.

Picture Credits

INDEX

Page numbers in *italics* refer to illustrations. Plants are indexed under their common names.